THE
ACRYLIC PAINTER'S
BOOK OF
STYLES & TECHNIQUES

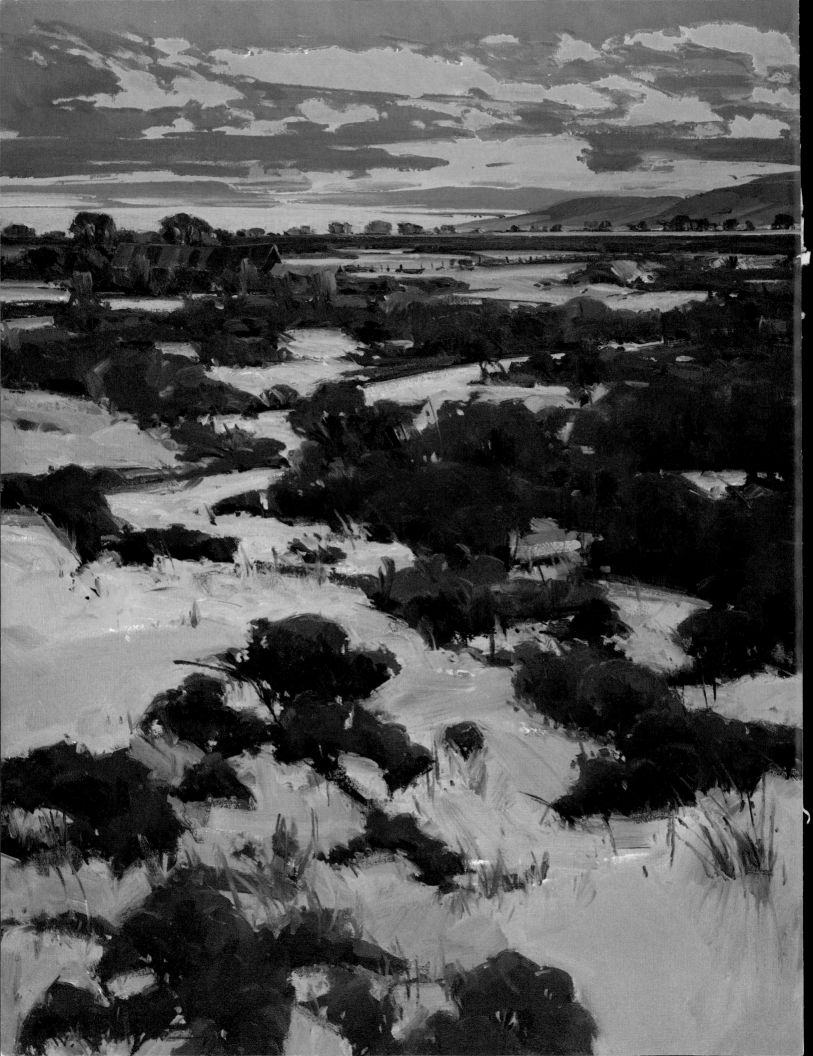

THE
ACRYLIC
PAINTER'S
BOOK OF
STYLES &
TECHNIQUES

RACHEL WOLF

NORTH LIGHT BOOKS
CINCINNATI, OHIO

The Acrylic Painter's Book of Styles & Techniques.
Copyright © 1997 by Rachel Rubin Wolf. Printed and
bound in Singapore. All rights reserved. No part of this book
may be reproduced in any form or by any electronic or
mechanical means including information storage and
retrieval systems without permission in writing from the
publisher, except by a reviewer, who may quote brief
passages in a review. Published by North Light Books, an
imprint of F&W Publications, Inc., 1507 Dana Avenue,
Cincinnati, Ohio 45207. (800) 289-0963. First edition.

Other fine North Light Books are available from your local
bookstore or direct from the publisher.

01 00 99 98 97 5 4 3 2 1

Library of Congress Cataloging-in-Publication Data

Wolf, Rachel
 The acrylic painter's book of styles & techniques /
Rachel Wolf.
 p. cm.
 Includes index.
 ISBN 0-89134-744-5
ND1535.W66 1997

 97-19358
 CIP

Edited by Joyce Dolan
Production Editor Katie Carroll
Designed by Sandy Kent

North Light Books are available for sales promotions, pre-
miums and fund-raising use. Special editions or book ex-
cerpts can also be created to specification. For details con-
tact: Special Sales Manager, F&W Publications, 1507 Dana
Avenue, Cincinnati, Ohio 45207.

METRIC CONVERSION CHART		
TO CONVERT	**TO**	**MULTIPLY BY**
Inches	Centimeters	2.54
Centimeters	Inches	0.4
Feet	Centimeters	30.5
Centimeters	Feet	0.03
Yards	Meters	0.9
Meters	Yards	1.1
Sq. Inches	Sq. Centimeters	6.45
Sq. Centimeters	Sq. Inches	0.16
Sq. Feet	Sq. Meters	0.09
Sq. Meters	Sq. Feet	10.8
Sq. Yards	Sq. Meters	0.8
Sq. Meters	Sq. Yards	1.2
Pounds	Kilograms	0.45
Kilograms	Pounds	2.2
Ounces	Grams	28.4
Grams	Ounces	0.04

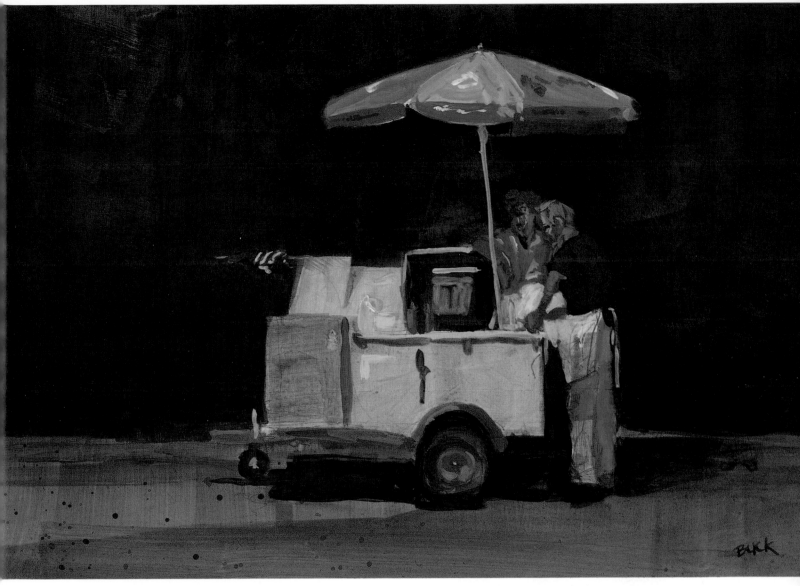

THE HOT DOG VENDOR
16" × 20", Lisa Buck-Goldstein

ACKNOWLEDGMENTS

I wish to thank content editor Joyce Dolan and production editor Katie Carroll for their work in taking care of the myriad details to get this book in shape to go to the printer. Thanks to Sandy Kent for the beautiful book design. I wish to thank Barb Richards for her timely and skilled help in inputting the first draft of the manuscript. Most of all, thank you Lisa Buck-Goldstein, Barbara Buer, Louise Cadillac, William Hook, Michael Nevin, Joseph Orr and Mary Sweet for their most generous contributions to this book. Each of you was a delight to work with, some for the first time and some once again. Though you each have your own clear vision and perspective, there was not one prima donna among you! I found each one of you easy to work with, wanting the best for the book and the reader rather than just a platform for yourselves. I wish you the best in all that you do.

TABLE OF CONTENTS

Introduction

The virtues and diversity of acrylics expressed by these master artists will inspire and motivate you, and give you the tools to succeed in painting with acrylics.

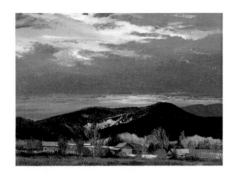

CHAPTER ONE

Textural Techniques Enhance Traditional Painting

Joseph Orr paints rustic country scenes.

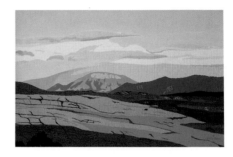

CHAPTER TWO

Brilliant Design With Flat Opaque Colors

Mary Sweet paints colorful outdoor scenes.

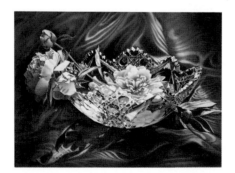

CHAPTER THREE

Ultra-Realism Using Acrylic as Transparent Watercolor

Barbara Buer paints dramatic flower still lifes.

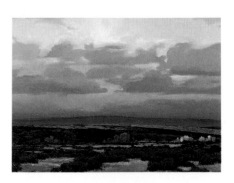

CHAPTER FOUR

Pulsating Color With Buttery Impasto Strokes

William Hook paints breathtaking vistas and lively flowers.

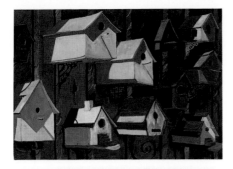

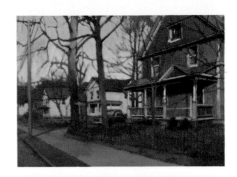

INTRODUCTION

Although acrylic paint has reached its forty-something birthday, it is still considered the "new kid on the block" by many artists. And rightly so, since oil and watercolor, in one form or other, have been around for centuries.

But in this century of rapid change, acrylic seems to have been a bit slow in gaining widespread acceptance. This may be due to the fact that the first artists to celebrate acrylic's astonishing flexibility and usefulness were the abstract expressionists of the 1950s, including Rothko and Motherwell. The op-art explosion that followed was due in part to the unique qualities of acrylics. As a result, acrylics gained the reputation of an "abstract" or "experimental" medium and was not generally considered by artists working in other styles.

It has only been in the past decade or so that a large number of artists of all interests and styles have "discovered" acrylics. This quiet revolution that crept up on the art world nearly unaware is gaining zealous adherents daily. It is for this reason that we put this book together: to help a variety of artists new to acrylics find their way and get ideas for using this "new" art medium.

No matter who you ask, the one word to describe acrylics is "flexibility." There are so many ways to use this wonderful medium, and they haven't all been discovered yet. Our intention is to show you as many ways as possible within these pages.

We have brought together seven top acrylic painters, each of whom uses the paints a bit differently and with a variety of results. Each shows, step by step, his or her individual techniques, as well as examples of finished work. Here you will find paintings that resemble highly controlled transparent watercolor, paintings that could have come from the abstract expressionism of acrylic's beginnings, and everything in between.

There is a lot to learn between these covers, as well as a good deal of inspiring art. But most of all, we hope you catch the excitement that these seven artists communicate about the flexibility, variety and, therefore, possibilities of acrylics.

Rachel L Wolf

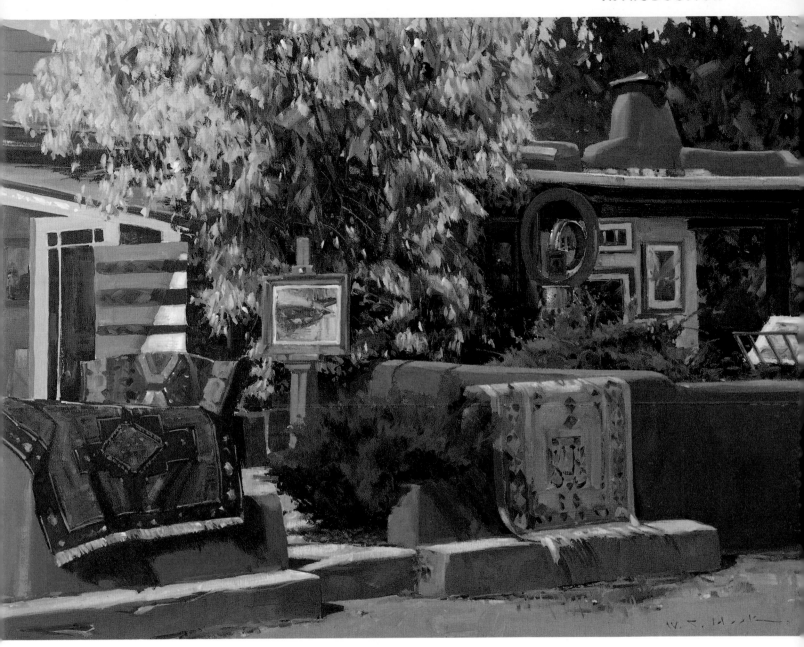

SANTA FE MERCHANTS
30" × 40"
William Hook

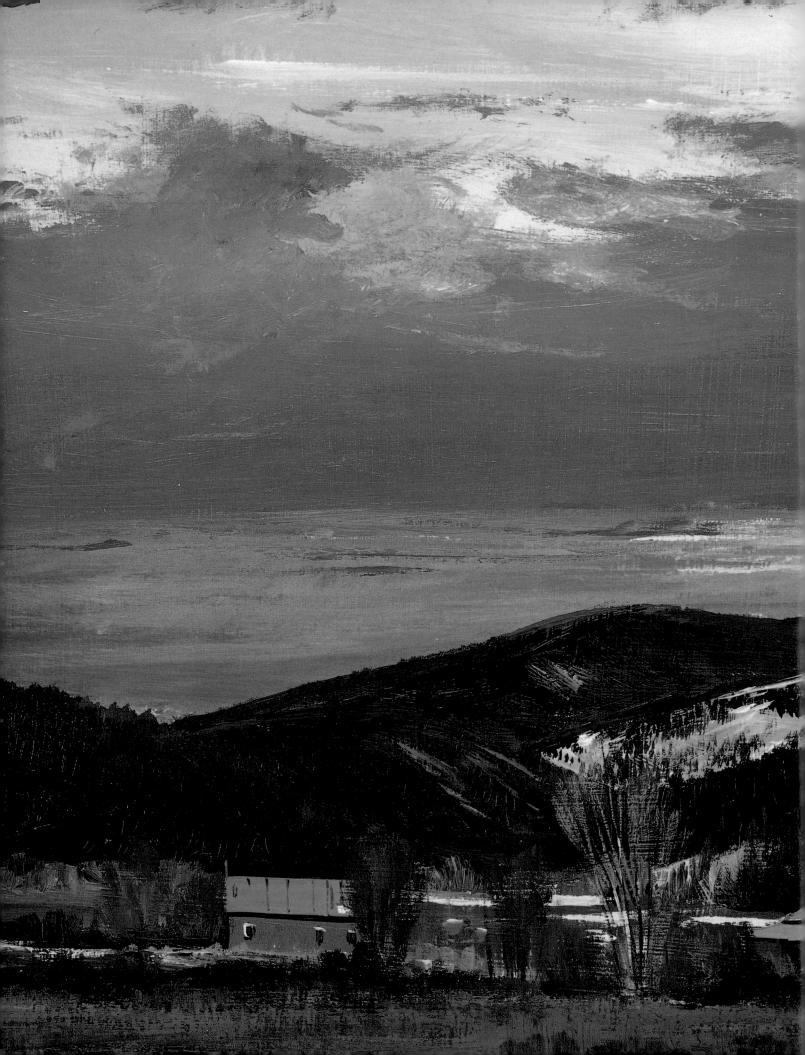

Textural Techniques Enhance Traditional Painting

Joseph Orr paints rustic country scenes

Since he was introduced to the making of art, Joseph Orr's life was consumed with painting and with finding ways to have more time to paint. A fellow artist introduced him to acrylic paint in the mid-seventies, and immediately he was entranced by its qualities: It dries fast, it is easy to transport for painting on location, it is durable, and clean-up is a snap. Also, it is flexible in the many ways it can be applied to canvas, Masonite or paper. Through experimentation, Orr has come to the conclusion that, no matter what the subject or manner of expression, acrylics can do it.

For Orr's approach, the strength of the medium is in using it like oil paint on either Masonite or canvas, interspersing a variety of techniques that would be impossible with oil. For instance, in creating an illusion of texture he uses different tools, such as a palette knife, plastic wrap or a paper towel, to manipulate the paint. These techniques, when used over a solid color or under a *glaze* of color, create a sense of depth and detail that would be tedious to achieve by any other means. For Orr, painting must be fun, not laborious. He doesn't try to make a ''philosophical statement'' in his paintings, but he does approach his subjects from a loner's viewpoint. He enjoys the tranquillity of standing at the top of a valley looking over the vista; his role as an artist is to provide a moment of escape, a therapeutic break for the eyes and the mind, and perhaps encourage a slower pace in the lives of urban viewers of his paintings.

MEMORY OF TAOS
12" × 16"
Joseph Orr

Create a Textured Effect

STEP ONE

Sketch With the Brush

Begin with a wash of paled down Ultramarine Blue over the entire canvas to cut down the glare of the white, especially when painting outdoors. This wash also provides a cool undertone for the painting. Then sketch out the idea of the painting using Burnt Umber, diluted and applied with a no. 4 synthetic, round brush. All you want is a simplified drawing layout. Use only a few lines, saving energy for the rest of the painting.

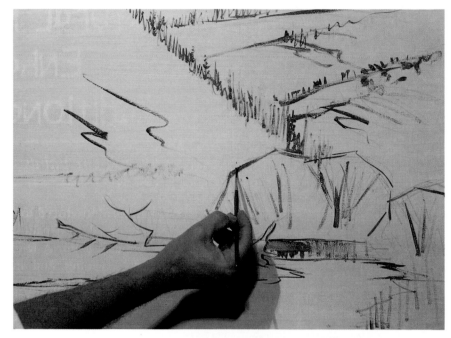

STEP TWO

Block In Large Areas

Shows top of painting: Start on the ground work, blocking in large areas at a time. All paint used is Liquitex. The sky is a mix of Ultramarine Blue, Titanium White and a little Portrait Pink for a warm gray tone that will recede. The background is grayed down by mixing Light Green Oxide, Yellow Oxide, Ultramarine Blue and a touch of Cadmium Yellow Light. Use a no. 8 flat brush. You need not be careful to stay within the lines of the sketch.

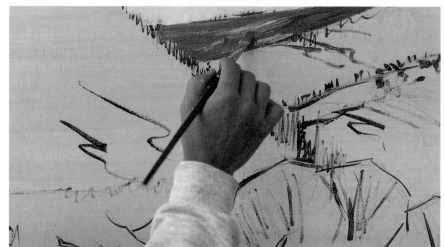

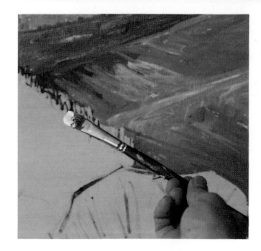

Load Your Brush

The idea is to get a free flow of color down. I like to use a lot of paint and really load the brush.

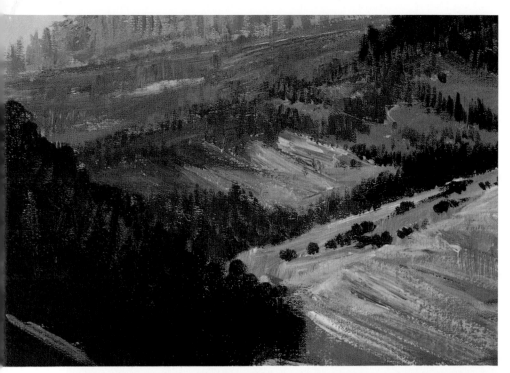

STEP THREE

Add the Darks

Detail of top center: With a mixture of Hooker's Green, Dioxazine Purple and Burnt Sienna, begin to fill the area of the dark trees. I use a no. 12 flat brush because there's a lot of space to fill. You want a sense of light against dark in patterns. To paint the background cedar trees on the right, use a no. 1 round, white bristle brush and mixtures of Hooker's Green, Ultramarine Blue, Burnt Sienna, Yellow Oxide and Titanium White.

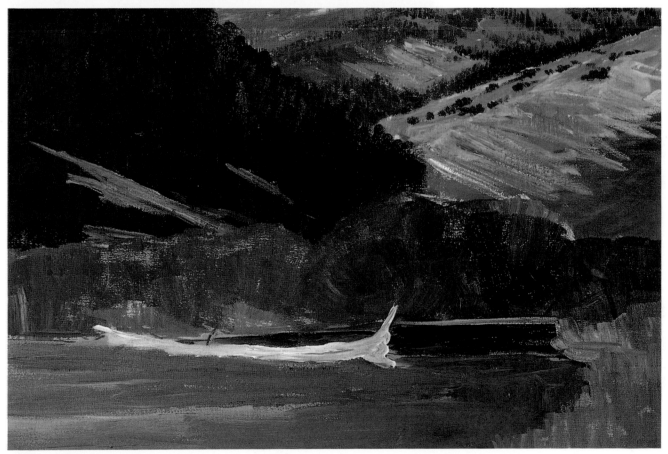

STEP FOUR

Create the Mid- and Foreground

At this point, paint in the color for the underlying design in the mid- and foreground of the painting.

STEP FIVE

Give the Beach Texture

To get the texture to emerge from the painting, drag a palette knife loaded with paint across the canvas. This leaves grooves and high spots that simulate gravel, raised pieces of driftwood and the uneven condition of the ground. Repeat the procedure until it looks right. Use this technique across the entire beach area of the foreground.

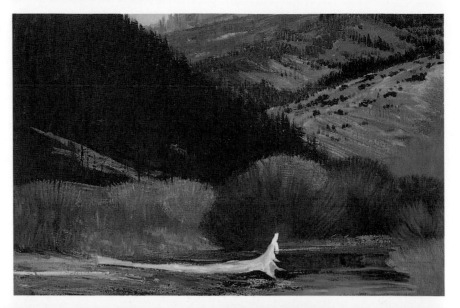

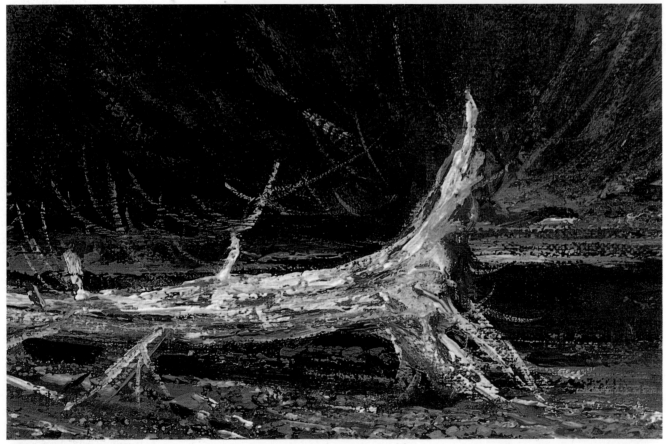

STEP SIX

Use a Dry Brush

A close-up of the fallen log reveals more textural effects, this time created by using a dry brush technique. Load a brush with mostly pigment (i.e., very little water), then drag it so the paint leaves a highly textured effect. This is easy to control and more efficient than painting every crack and crevice with a tiny brush. I used a no. 1 bright bristle and a no. 1 round bristle brush. I then used a no. 1 script brush for the small limbs.

STEP SEVEN

Continue With the Dry Brush

Detail: Use this dry brush technique on the bushes at midground.

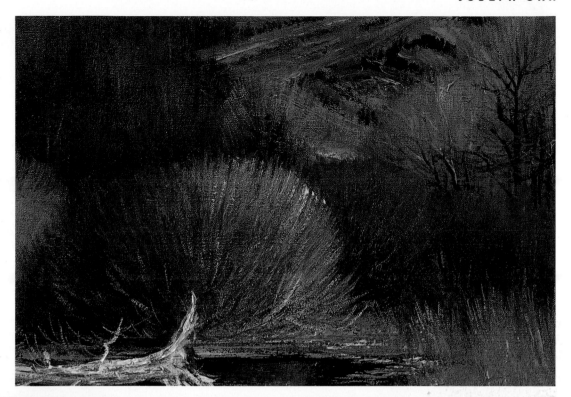

STEP EIGHT

Use a Bristle Fan Brush

Use the dry brush technique a third time but with a no. 4 bristle fan brush. The distinctive needles on the pine trees are painted quickly and convincingly.

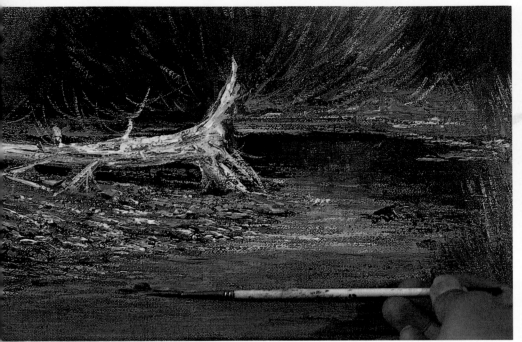

STEP NINE

Add Finishing Details

Save any detailing such as ripples on the water, little stems of grass and small limbs for the end of the painting. Doing this last enables you to see how much highlight to add to any particular part of the painting. To add just what needs to be there for the finishing touch, use a no. 1 script brush.

RUSH HOUR
18" × 24"
Joseph Orr

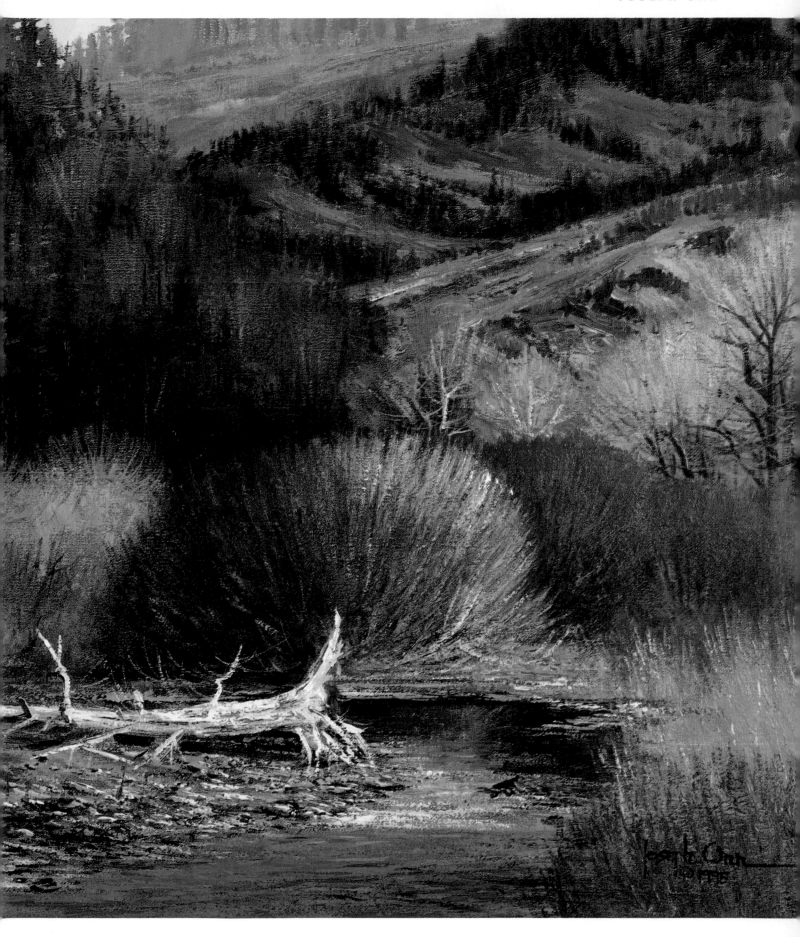

Spray Varnish for a Beaded Effect

By lightly spraying varnish on a small area of the painting and applying diluted pigment to that sprayed area, you can achieve a "beaded" effect. It is very effective in snow scenes, but I caution you not to overdo this technique. A clear gloss spray varnish for acrylic by Liquitex was used here.

Important: If you use this technique, you should varnish the entire painting again when it is complete. This will assure that the paint on top of the varnish will adhere permanently.

STEP ONE

Paint an Undercoat
Paint your undercoat (usually a dark color, such as that of a tree branch) and let that dry.

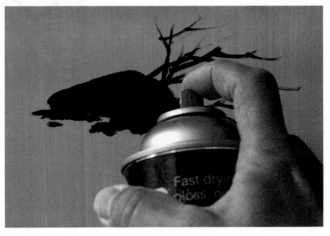

STEP TWO

Spray the Varnish
Lightly spray the varnish on the part you want to texture. Let the varnish dry.

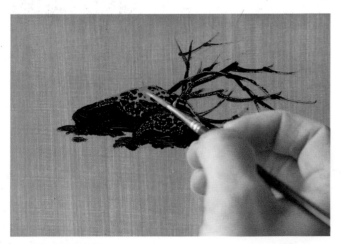

STEP THREE

Create a Beaded Effect
Dilute another, usually lighter, pigment with water—a bit thinner than usual—and drag your brush across the area. When the paint hits the surface, the varnish separates it. Some adheres and some doesn't, causing the beaded effect.

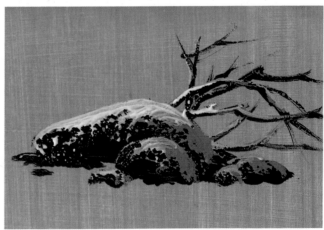

STEP FOUR

Finish
After adding a bit more white for snow, the result looks like this. (This technique is also used in the demonstration for the painting *Hollow Secrets*.)

Use Plastic Wrap for the Effect of Swirling Water

STEP ONE

Make a Sketch

Determine where the water will be placed within the painting. Sketch the shape, and block in that area with acrylic color in a lighter shade.

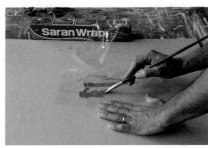

STEP TWO

Use Plastic Wrap

Cut a small piece of plastic wrap and lay it flat on a table. Apply a *liquefied* pigment (that is the key to this technique) directly onto the plastic wrap. The color should be darker than the color used to block in the basic shape of the stream.

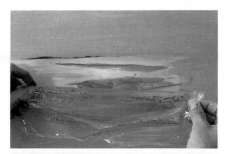

STEP THREE

Work in the Direction of the Water Flow

Lift the plastic wrap up to the painting and lightly touch it to the surface of the painting, dragging the folded sections of plastic across the painting in the direction in which the water is to appear to flow. It may take two or three attempts for you to understand how to create the effects possible with this technique.

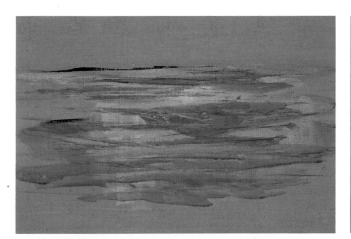

STEP FOUR

Here is the area after the plastic wrap was applied to the painting.

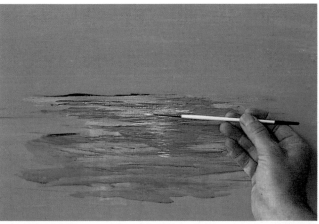

STEP FIVE

Add Highlights

Finish the water technique by taking a well-loaded script brush and applying the light pigment to highlight areas of reflected light.

Develop a Snow Scene

STEP ONE

Make a Preliminary Sketch
Working from thumbnail sketches, do a brief painted sketch on your canvas.

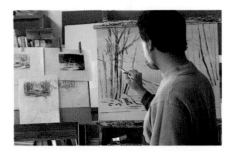

above

STEP TWO

Complete the Sketch
Used a wash of diluted Ultramarine Blue and Titanium White to avoid a harsh glare from the white of the canvas. I have drawn in the basic outline of my composition with diluted Burnt Umber. The sketch is not detailed—only the basic idea. This allows ample opportunity for creative maneuvering as the painting progresses.

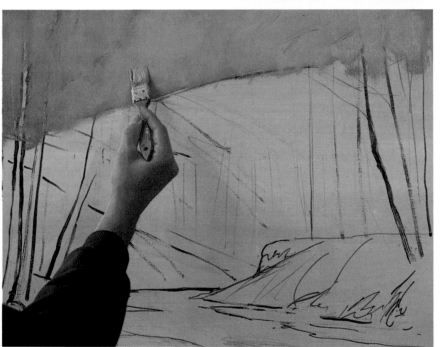

left

STEP THREE

Block In Color
Block in large portions of color, working from the top of the canvas to the bottom using a 1-inch white bristle brush.

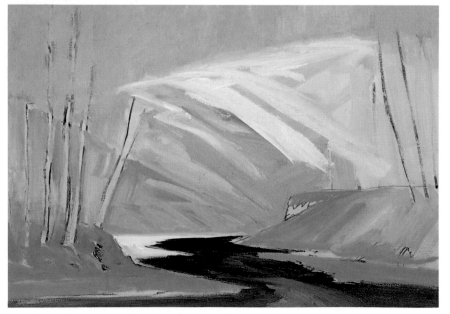

STEP FOUR

Finish Blocking In Color
Don't be concerned with staying inside lines, but only with establishing color patterns within the composition. I use mixtures of Ultramarine Blue, Phthalocyanine Blue, Dioxazine Purple, Mars Black and Titanium White in different proportions depending on light or dark areas. Since this is a snow scene, start with cool colors. I add some Hooker's Green in my mixture for the dark water of the stream. Even at this stage texture is already beginning to emerge.

STEP FIVE

Place Background Trees

After blocking in, place the background trees. This is done with a worn no. 1 round bristle brush using a mixture of Ultramarine Blue, Burnt Umber and Titanium White. Notice how I hold the brush with my thumb and index finger and use a quick downward stroke to achieve the impression of distant trees.

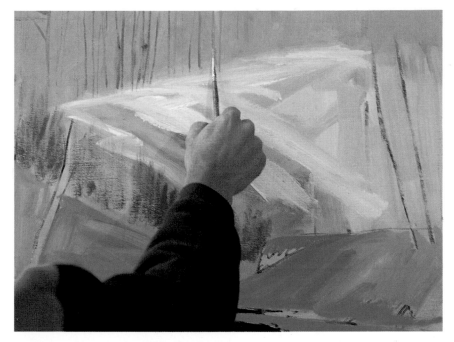

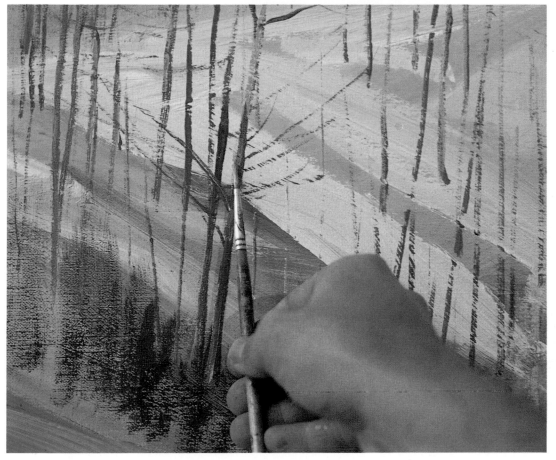

STEP SIX

Paint Highlights

Detail: Paint in highlights on some of the trees by loading the brush and dragging it in a downward stroke, magically giving the illusion of rough texture on the tree bark. For highlighting, I use Yellow Oxide, Burnt Sienna and Titanium White.

STEP SEVEN

Use a Dry Brush

Paint in the underbrush of the forest with the same 1-inch white bristle brush you used for blocking in the first stages of the painting. Use a dry brush technique with a mixture of Titanium White, Yellow Oxide, Burnt Umber and Dioxazine Purple.

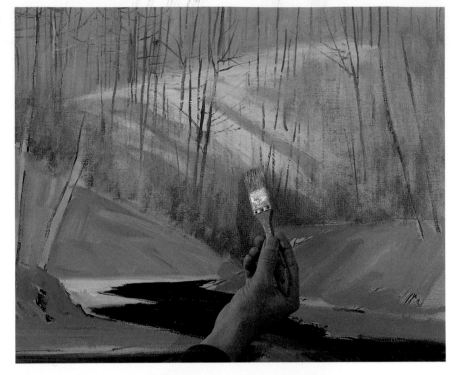

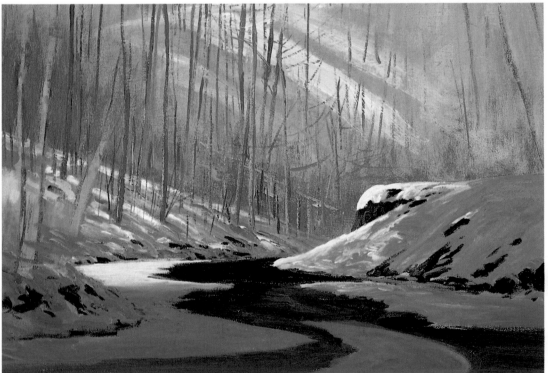

STEP EIGHT

Use Short Strokes for Highlights

By using quick, short strokes, highlight the ground where the sunlight bounces off, giving the illusion of deep snow. For this, use a no. 1 and no. 2 white bristle bright square brush and a no. 1 round bristle. The colors for these intense highlights are Light Portrait Pink, Cadmium Orange and Yellow Oxide, each mixed with Titanium White and applied individually. This gives the work a sense of the direction of light and varying color in the snow, reflecting the surroundings. At this time, you can also add a few bigger trees in the midground.

Thick Pigment for Texture
Using a lot of pigment for the bright highlights automatically creates texture, not only of the snow, but the rocks underneath.

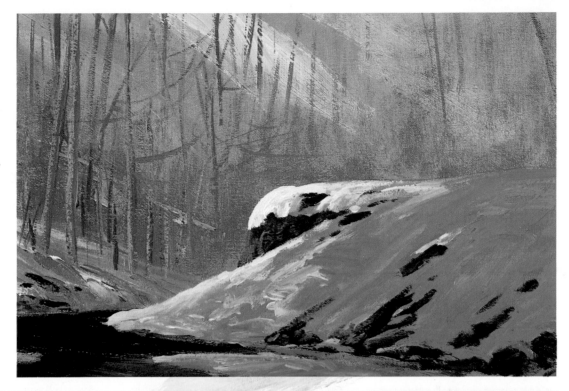

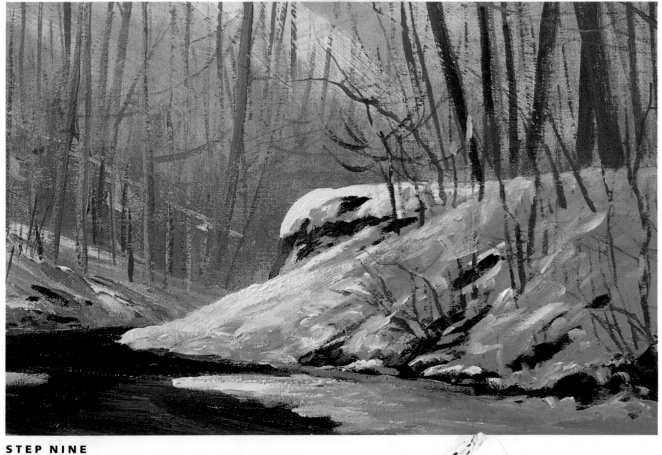

STEP NINE

Create More Texture

Detail: Notice the emergence of texture on the right side of the painting, due to a generous use of pigment. Add the tall dark trees and brushy twigs coming up through the snow.

STEP TEN

Define the Center of Interest

Detail of the left side of the painting: A more intense sense of light filtering through the trees from left to right will strengthen the composition and make a distinction of the center of interest, so paint in a light area using the dry brush technique behind what will become the foreground trees. For this I use Yellow Oxide and Light Portrait Pink, both mixed with Titanium White.

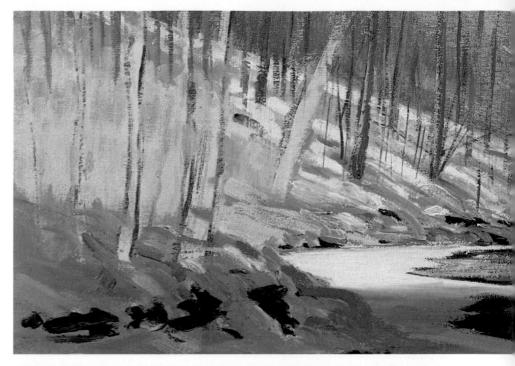

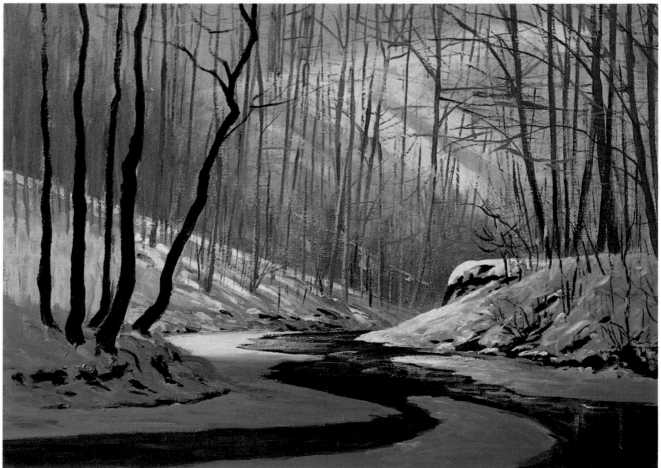

STEP ELEVEN

Create Drama

Now paint the foreground trees in shadow. Put the light color behind these trees first, and then paint them in a dark color to heighten the drama of the entire painting.

Close-up of the trees in shadow on the left side.

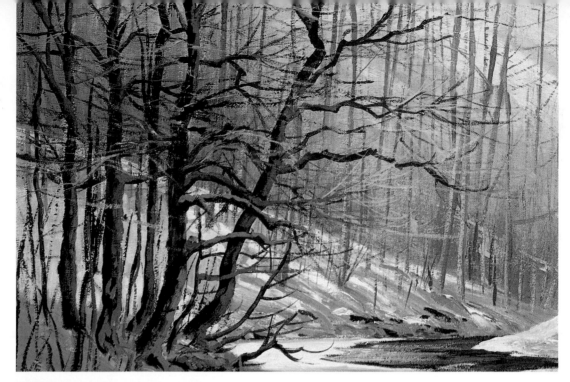

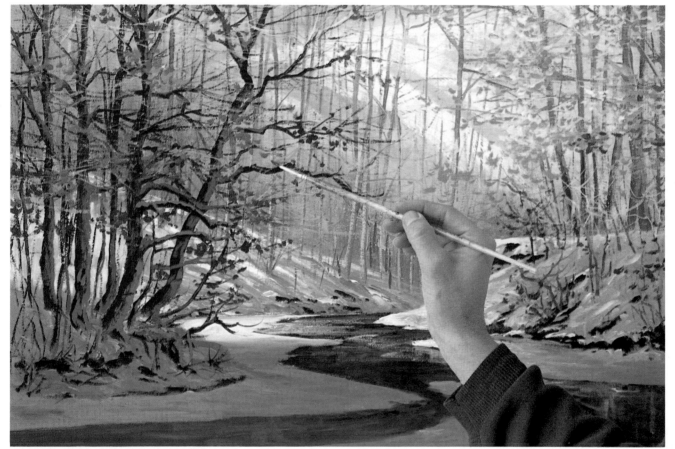

STEP TWELVE

Add Warmth

Some oak trees have their leaves all winter, which is great for the artist. They give a sense of movement to the scene and allow for the addition of warm colors. Colors for shadowed leaves on left: Burnt Sienna, Burnt Umber, Acra Violet and a touch of Cadmium Orange. Colors for sunlit trees on right: Yellow Oxide, Acra Violet, Cadmium Orange and Cadmium Yellow Light, all mixed with Titanium White.

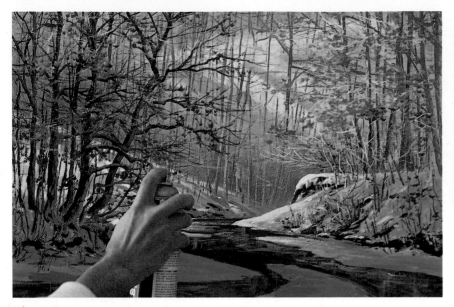

STEP THIRTEEN

Spray Varnish

I lightly sprayed two small areas with spray varnish to add snow texture using the technique shown on page 18.

Detail

Close-up of shadowed area on the left side of the painting where the spray varnish technique is used.

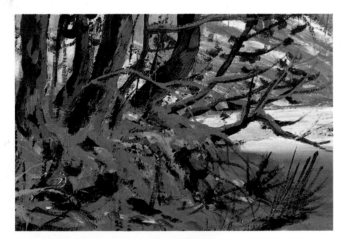

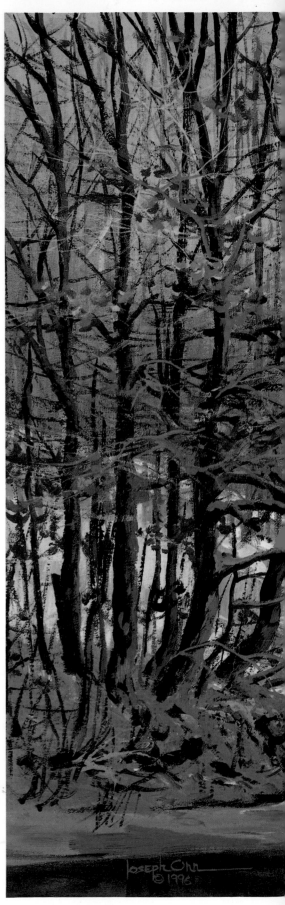

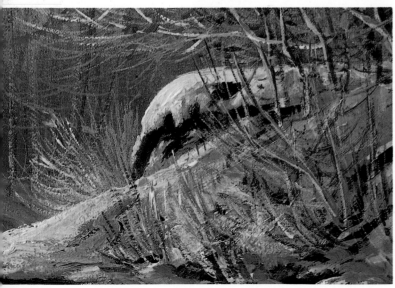

Detail

I used the spray varnish technique again on the small branches of the twigs around the rock outcropping to simulate clinging snow.

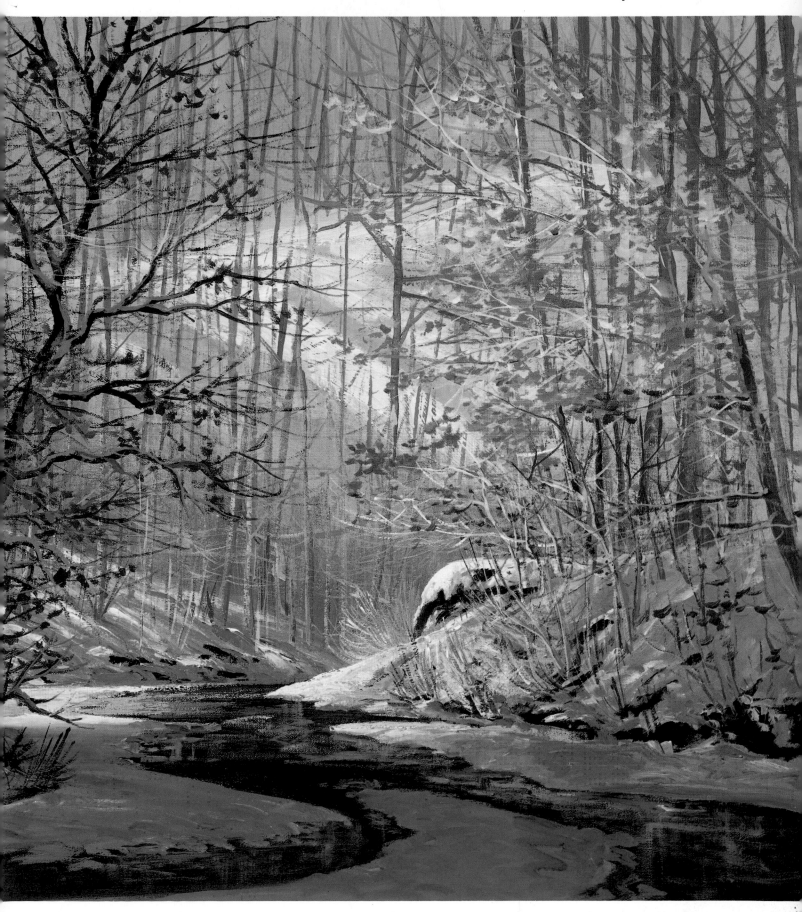

HOLLOW SECRETS *22" x 28", Joseph Orr*

Orr Gallery

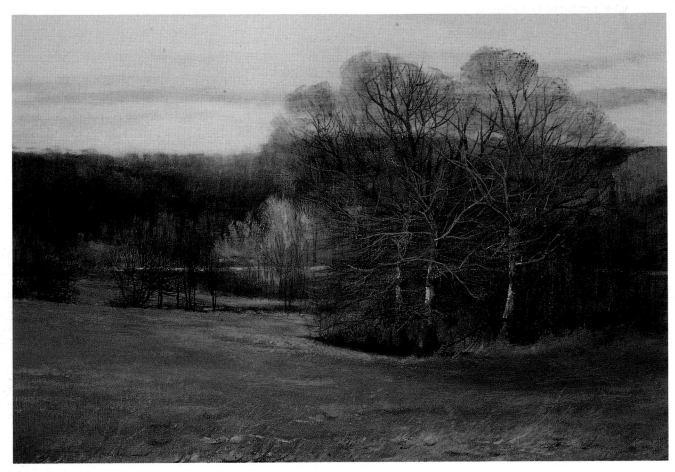

VALLEY SHADOWS
20"×24", Joseph Orr

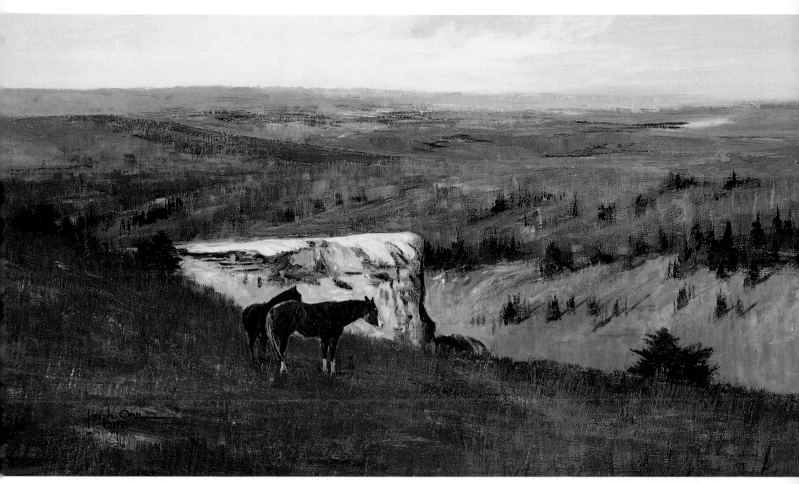

DISTANT GREEN PASTURES *22"×28", Joseph Orr*

PERSIMMON HONEY *22"×28", Joseph Orr*

Brilliant Design With Flat Opaque Colors

Mary Sweet paints colorful outdoor scenes

Mary Sweet began painting with acrylics in the mid-sixties, when acrylics first became widely available. Before that she used oils and watercolors, but the chemicals and slow drying time of oil paints became a problem after her son was born. In her early years she would paint in the kitchen sitting on the floor with canvases leaning against the stove and refrigerator. When her toddler son started to walk and get into things, she worried about him putting something toxic in his mouth or sticking a hand into a wet painting. Friends who ran an art supply store introduced her to acrylics and she's used them ever since. "First I tried using them just like I used oils on canvas," she says, "and found they did everything I wanted, except perhaps thick impasto. They dried rapidly, cleaned up with water and didn't have all the toxicity problems. I became an enthusiastic convert and never went back to oils."

She tried using acrylics as transparent watercolors and found that worked too. In addition, unlike watercolor, the colors didn't fade when dry and washes in layers didn't turn to mud. Over the years her painting style has changed, but acrylics have always done whatever she needed them to do. Currently, she uses acrylics on paper just as she would on canvas. She still uses watercolors for painting outdoors in the hot dry southwest where she lives, a climate that dries acrylics too quickly.

When she lived in the east or in California, the hazy skies, soft greens and golden rolling hills suggested a more impressionistic style. But after moving to New Mexico, the clean air, bright sunlight, sharp blue shadows and colors of the unvegetated land called for the crisp, hard-edge style she paints today.

FROM KING MESA
15"×22"
Mary Sweet

Mary Sweet's Basic Painting Process

1 She finds a wonderful place where the grandeur of nature and the land is still visible, usually by hiking, backpacking, or possibly skiing or river-running.

2 She takes numerous photographs (with 35mm slide film) and often does small watercolors with a portable watercolor set.

3 At home she reviews her slides with a small handheld viewer and does thumbnail sketches to decide what to paint. She draws from the slides as if she were viewing the landscape live—she doesn't project them onto the canvas.

4 She does a rudimentary drawing of the basic shapes of the landscape in pencil on the canvas or paper. She doesn't draw in detail, since it will just be painted over. Instead, she works more like an abstract expressionist, evolving the painting as it goes along.

5 She usually starts painting at the top with the sky, and then works her way down. If each part works with what has gone before it, by the time she reaches the bottom, the painting is finished. She adds details as she goes along, section by section, trying to contrast detailed areas with simpler ones for variety. If she doesn't like something, she redoes it.

6 Her goal is a flat opaque surface, so she sometimes goes over an area three or more times to get it smooth. Any change or adjustment in color happens then as well. There is a point when the painting begins to *gel*, to come together, that is always exciting. Although each individual area is flat, when she is finished, the whole painting has depth and distance.

7 She paints the four edges of the canvas as she goes. Not only does this eliminate the need for a frame—she prefers it that way.

HOODOOS, BRYCE CANYON
38" × 30"
Mary Sweet

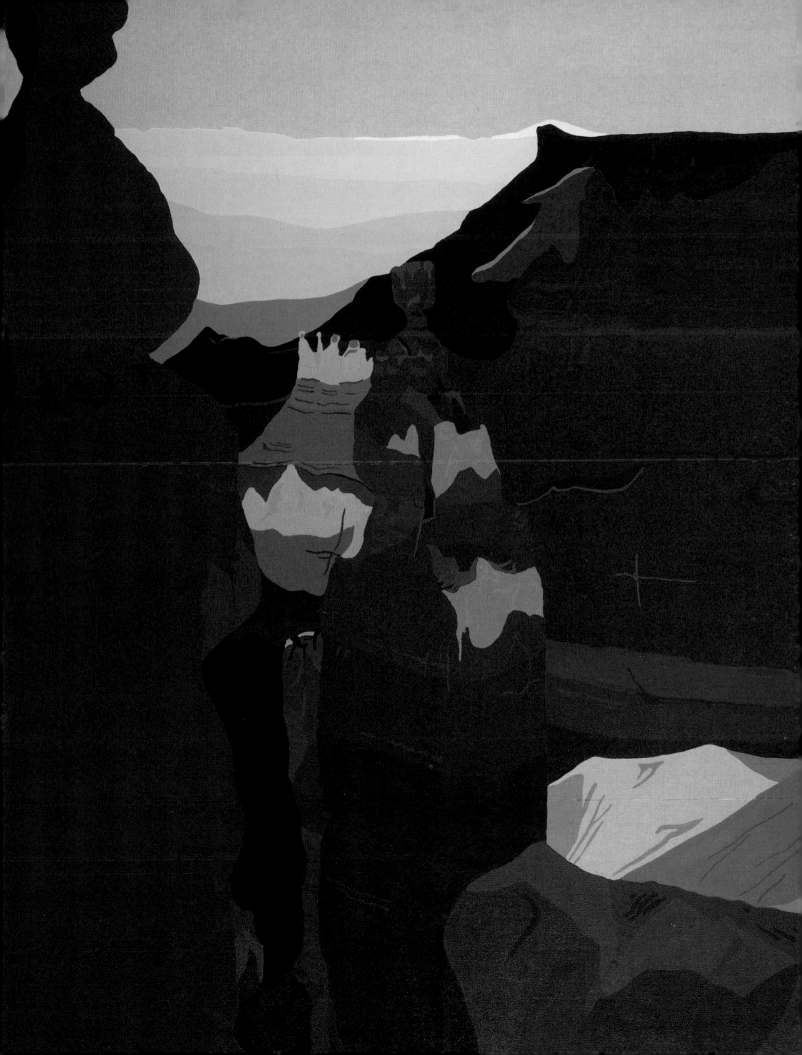

Design the Painting as You Go

STEP ONE

Begin With a Sketch
Your cotton canvas should be stretched, gessoed and sanded on 30″ × 38″ heavy-duty stretcher bars. Lightly sketch, in pencil, the basic shapes on the canvas. Start painting with the sky, using white with a bit of Cadmium Yellow, and then put in the blue distances on the left. Add the timbered ridge and also the forest below the blue distances.

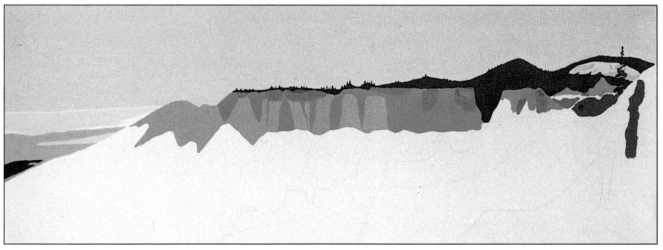

STEP TWO

Detail of the top half of the painting: For the top of the painting, put in the orange and pink sheer cliffs, make the green tree line more irregular and try out a lighter green line on the right where a tall tree will go.

TIP: Mix Paint With Old Brushes

Save a few old splayed brushes to mix paint on your palette. Mixing paint is hard on brushes and splays the hairs of the brush, so mix with old ones and only use them to paint where they don't go near an edge. That way the good brushes stay well shaped longer.

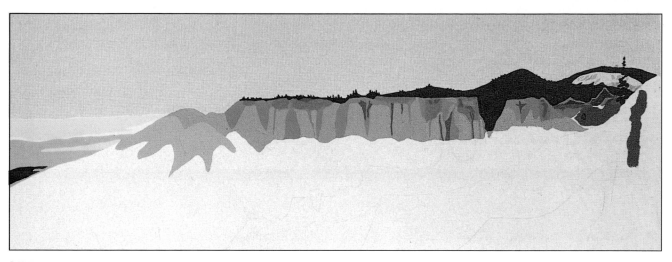

STEP THREE

Add Details

Top half of painting: As you work, add details, try out colors, paint over colors.

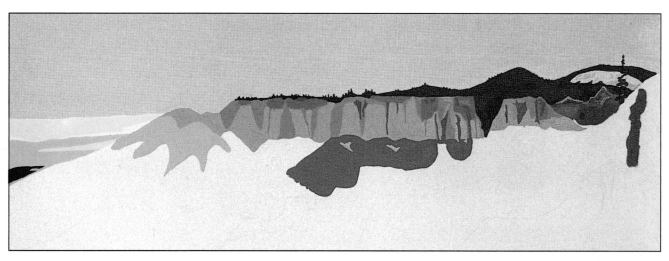

STEP FOUR

Test Color

Top half of painting: Try out the color for the forest area below the cliff band.

TIP: Use Paper Palettes

The slick and shiny kind of paper palettes don't dry up as fast when misted, but when they do dry, flakes of dried paint will mix into the fresh paint if you aren't careful. Keep a pair of tweezers handy and a push pin to pick them off the paper or canvas before they dry in the paint. If they do dry in the paint they won't come out easily, if at all.

STEP FIVE

Detail: Work on the forest area, putting in the shadows and backlit ridges. Work also on the next row of orange cliffs on the upper right, working back and forth between the greens and oranges.

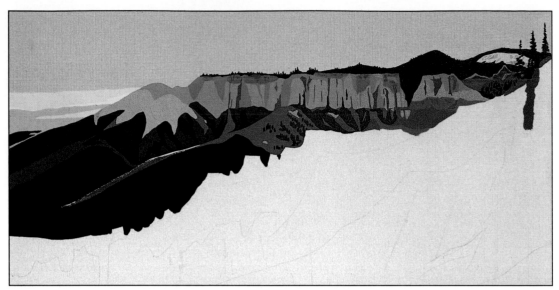

STEP SIX

Detail: I like to try odd things—like this turquoise color. I'll leave it if I like it, but I'll paint it out if I don't. In this case, I like it.

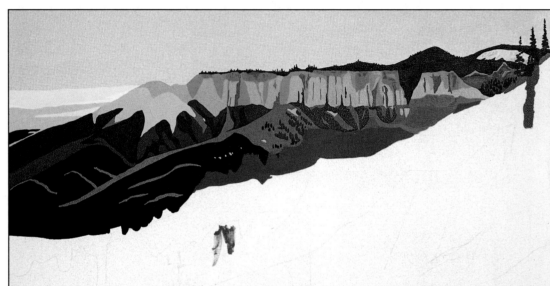

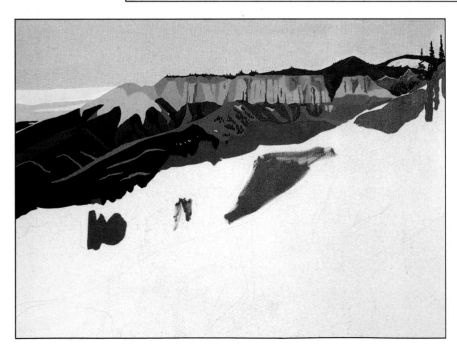

STEP SEVEN

Work Down

Work your way down the cliff layers. Add darker variations and use a bit of the same color on the upper cliffs too.

STEP EIGHT

Add More Details

Put in more details. (I use up some orange paint by putting it on in the vicinity of the next orange. I'll do this at the end of the day or when I know that paint would otherwise dry up, so as not to waste it.)

below

STEP NINE

Detail of upper right: Vary the colors and shapes within the red cliffs. With the very complex interactions of shapes here, it's important to see the patterns that the light on the land and the land itself form. Here there will be a triangle of blue shadow, there a J-shaped gully. Look carefully at what you are seeing, in either the actual landscape or a slide, to make sense of it.

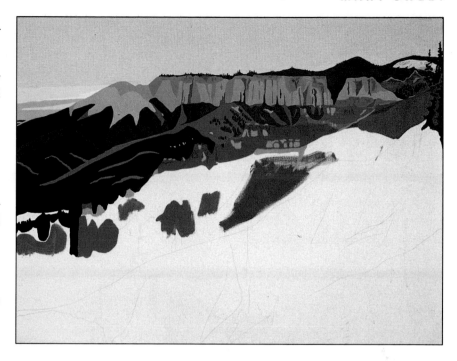

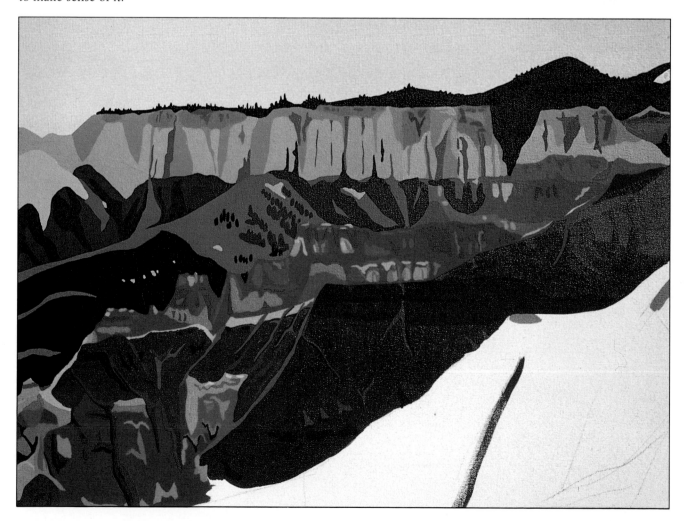

STEP TEN

Make It Convincing

Work on the lower left orange cliffs, alternating with the green trees in the middle. This part of the painting is slow because it's complex with no big areas to make progress more apparent. I try to put in as few details as I can and still have the eye "read" it and fill in the rest. I'm not interested in photo realism or in putting in every last detail, but I do want it to look convincing.

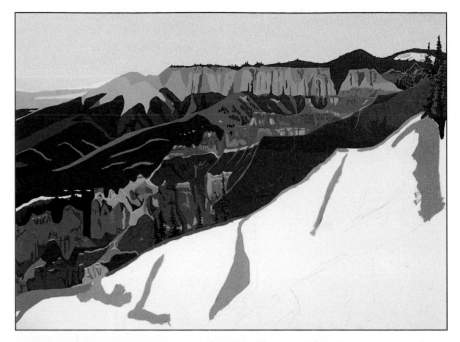

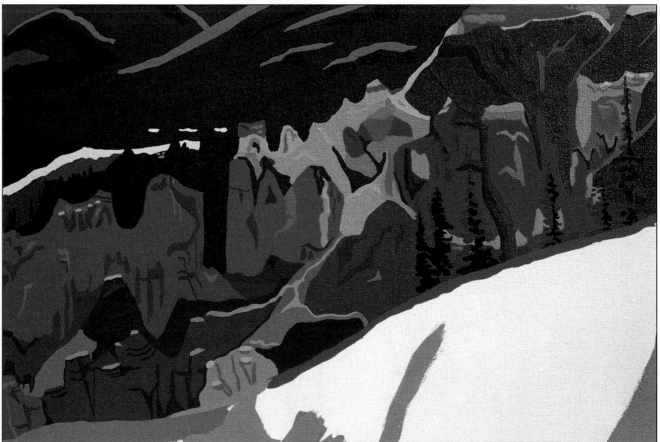

Detail of Orange Cliffs

TIP: USE TUBE PAINTS

I like to use tube paints more than jars because of the consistency of the paint and the ease of mixing. With a jar of paint, I'll eventually contaminate it with a dirty brush.

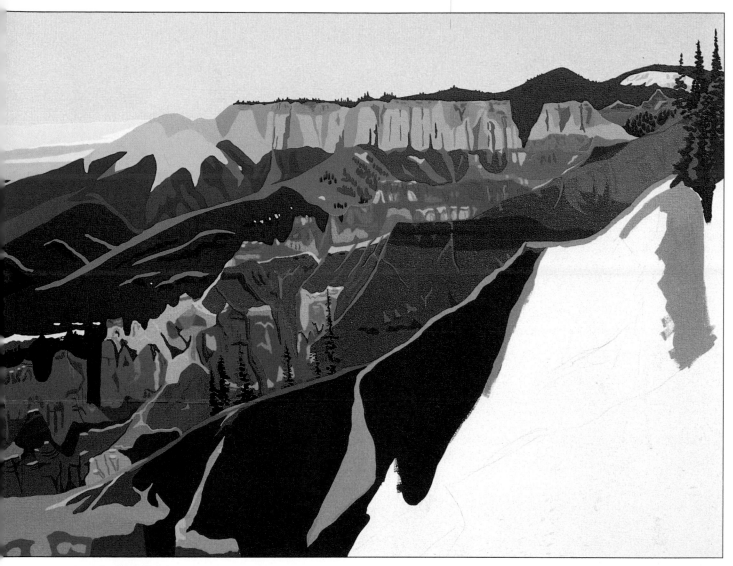

STEP ELEVEN

Work on Large Areas

I try the dark maroon color and then mix lots in a peanut can so it will keep several days. It's a relief to have big areas to do after all that fine detail. The play between detailed areas and large flat areas makes a more interesting painting. Add more shapes and details in the bottom left. Try to make the painting crisp and clean, but keep in mind that this is a painting, not a mechanically produced object, and that perfection isn't the goal.

> **TIP: BLOT EXCESS WATER**
> Keep paper towels under your water pots to wipe the brush on after rinsing. This way you won't have water running down the ferrule into the paint and forming a blob on the paper or canvas. Just in case, keep a tissue around for quick clean-up. Overmisting the palette can thin the paint too much, causing the same thing to happen.

STEP TWELVE

Finish the Cliffs

Work back up from the finished lower left cliffs, finishing the maroon cliffs and starting to daub in colors for the lower right area.

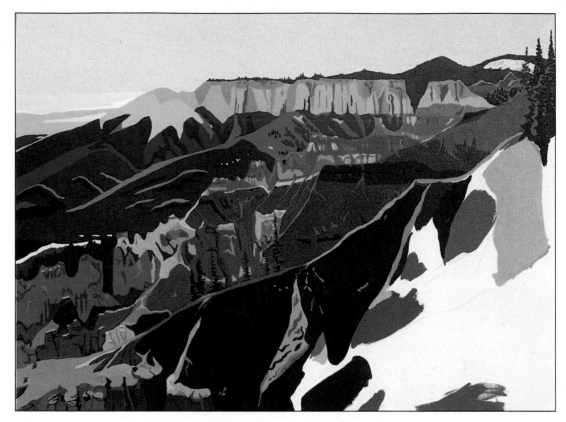

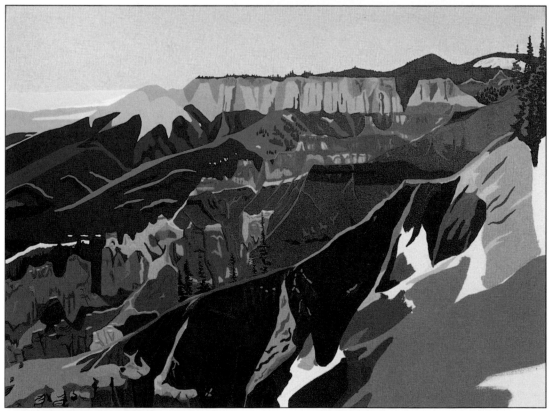

STEP THIRTEEN

Paint the Background First

Since trees will cover parts of the lower right, you must paint in the background first, even though you'll cover some of it up. Mix the extensive Pale Red Oxide cliff color in a can so it will keep. You can alternate it with tree parts later.

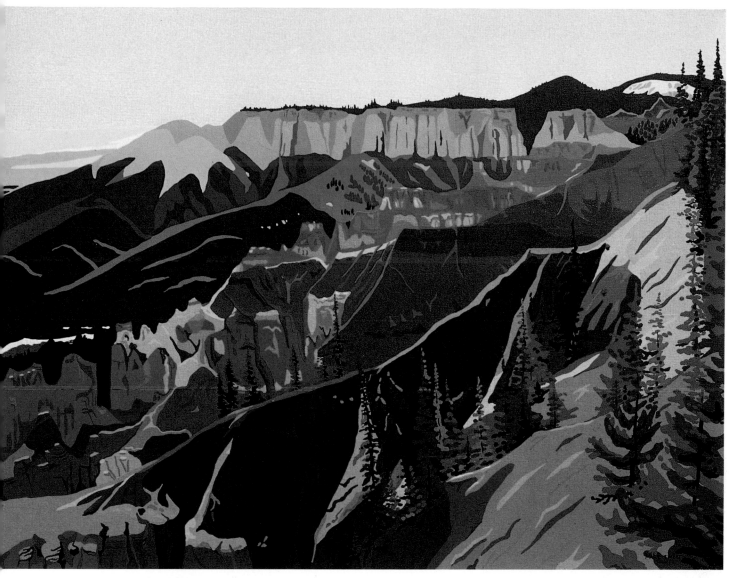

BENEATH THE RIM, BRYCE CANYON
30"×38", Mary Sweet

STEP FOURTEEN

Finish the Painting

Painting in the trees is truly tedious to me. I am so near, yet so far from, being finished that by now I am ready to quit. This is where I can really mess up through haste or lack of concentration. (Another reason to keep cans of paint—possible repair!) I tell myself it's just like hiking, one foot in front of the other until I get there.

> **TIP: Stay iN CoNTroL**
> I sometimes have trouble with looser styles getting out of hand and turning into a mess. The discipline of this style is helpful, yet, because I paint this way in a fairly spontaneous manner, I don't feel oppressed by the discipline. And I'm the one who controls it.

Sweet Gallery

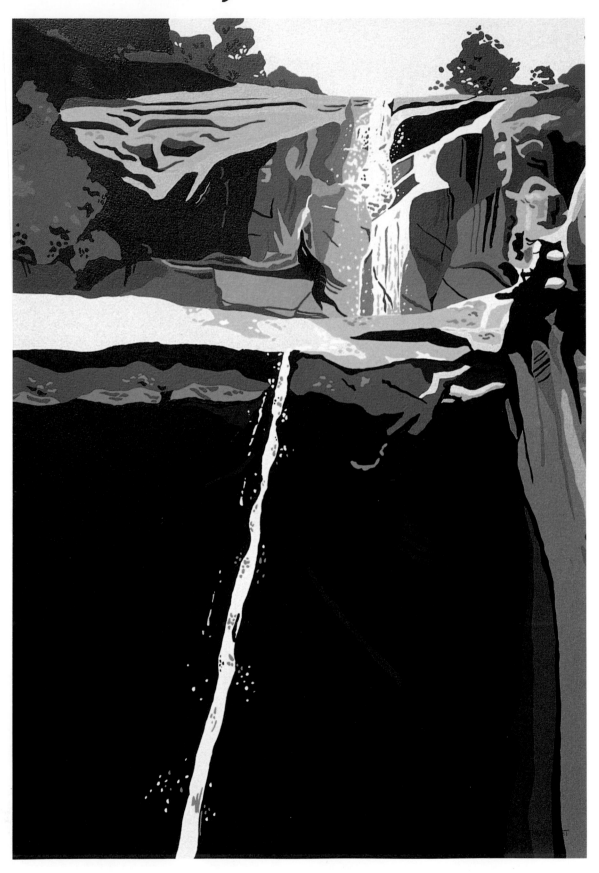

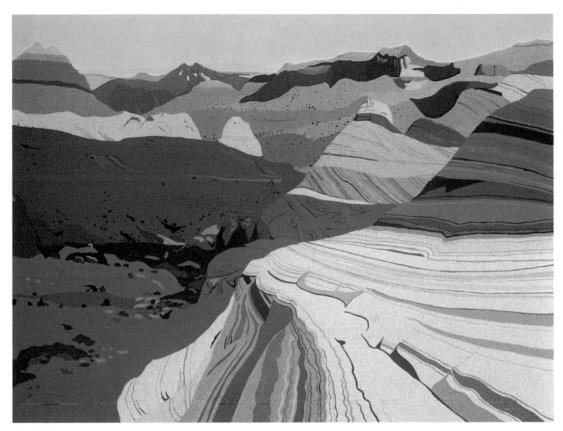

SAND WASH, GREEN RIVER *48" × 72", Mary Sweet*

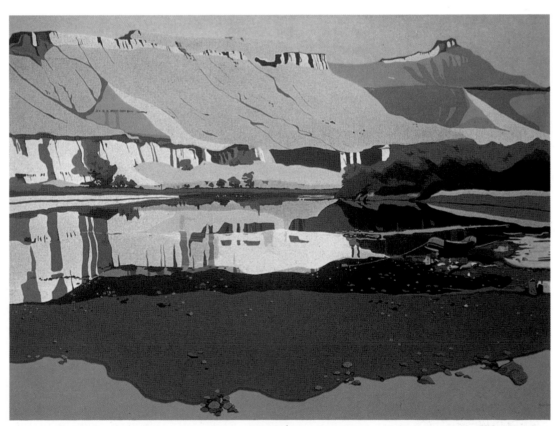

left
GROTTO,
RIPPLING
BROOK
30" × 22"
Mary Sweet

COLORADO PLATEAU SERIES #1 *36" × 48", Mary Sweet*

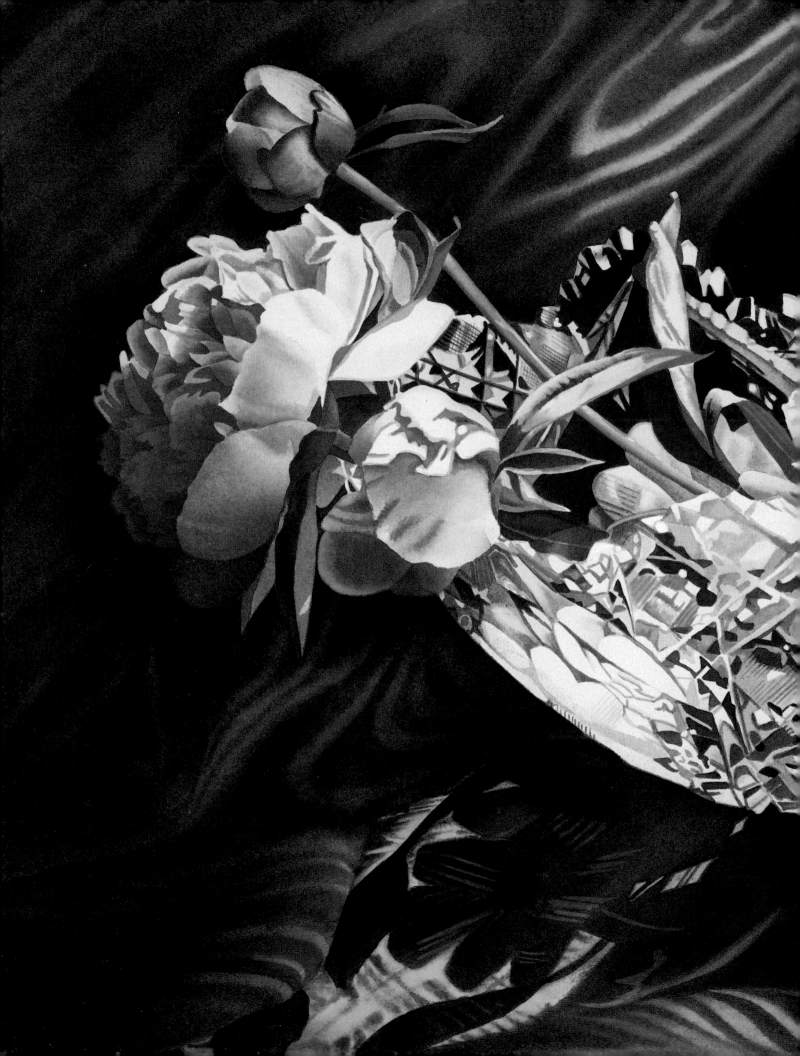

Ultrarealism: Acrylic as Transparent Watercolor

Barbara Buer paints dramatic flower still lifes

Barbara Buer finds beauty in the world we see each day. Her paintings are about the exceptional color of one special flower, the interesting shadows cast by the intricate cuts in a crystal vase, or the sunlight bathing a wonderful still life.

Her technique of painting watercolor-style paintings with acrylic paints evolved over a number of years. She was never satisfied with sketchy-type watercolors, and continually strived to create watercolor paintings with deep values and strong contrasts. As this challenge progressed, so did the size of her paintings. She felt stymied because she couldn't execute a large, smooth, dark passage satisfactorily in watercolor. Dark backgrounds are an intricate and important part of her paintings and she relies heavily on the two extremes of the value scale. One day, while trying to paint a large, dark background, she ran out of watercolor paint and, in utter frustration, picked up a tube of acrylic, diluting it to the consistency of a watercolor glaze. After painting the area with the acrylic, she discovered she could repaint it again and again by drying each thin glaze and painting another right over it without disturbing the underlying paint. She used this method of painting backgrounds for quite some time until she finally began using acrylics exclusively.

PEONIES, CRYSTAL & MOIRE
22" × 30"
Barbara Buer

Barbara Buer's Basic Technique: Using Acrylics Like Watercolor

When Barbara Buer started using acrylics she used tube colors, and even heavy-bodied acrylics, both of which must be thinned out considerably to achieve watercolor consistency. She was introduced to ink-like airbrush acrylics, which she used satisfactorily for a while, and then discovered Golden Fluid Acrylics, which she has used ever since.

Buer's Golden Fluid Acrylic Colors:
- Titanium White
- Hansa Yellow
- Yellow Oxide
- Quinacridone Burnt Orange
- Pyrrole Red
- Quinacridone Red
- Quinacridone Magenta
- Phthalo Blue
- Dioxazine Purple
- Phthalo Green
- Payne's Gray
- Carbon Black
- Burnt Umber

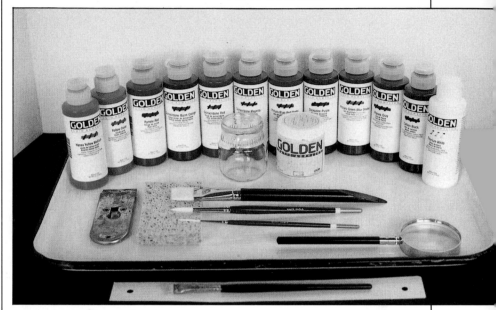

Palette and Materials

Here are the basic materials Buer uses: butcher's tray, twelve Golden Fluid colors, three Robert Simmons brushes (1-inch white sable flat; no. 6 white sable round; no. 3 white sable pointed rigger), masking fluid, empty baby food jar to contain large amounts of thinned paint for glazing, reducing glass to relate specific portions of a painting to the whole, strip of paper to check values, short bristle brush to loosen and lift paint, sponge to wipe wet paint from the butcher's tray palette, and paint scraper to remove dried paint from the tray.

TIP: Clean Up

I use a butcher's tray as my palette. On this surface the acrylics, when dry, are easily removed by running the tray under warm water and wiping with a nylon covered sponge. I am careful to not let the acrylic paint dry in a brush, however. It can be worked out using denatured alcohol, but it is much wiser to develop the habit of always rinsing the brush before placing it down.

DEMONSTRATION

Use Acrylic as Watercolor: *Poinsettia*

STEP ONE

Paint Background and Begin Poinsettia

Paint the background with approximately ten glazes of thin fluid acrylic paint using a large, flat, white sable brush, drying each layer before applying the next. The colors used were Phthalo Green and Carbon Black. Paint the poinsettia petals with Hansa Yellow one at a time in order to preserve the edges, and while wet, use a paper towel to wipe out the highlights.

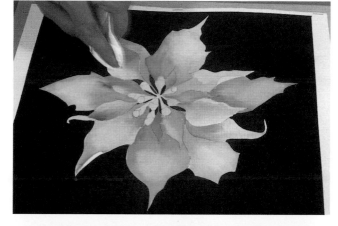

STEP TWO

Glaze One Petal at a Time

Glaze each petal, one at a time, with various red fluid acrylics paints. Deepen the color at the base of the petals to allow the lower petals to recede, the upper ones to come forward. I use a no. 6 round white sable brush.

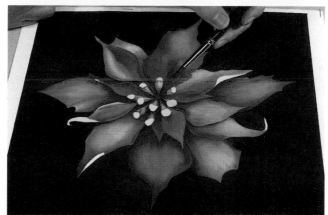

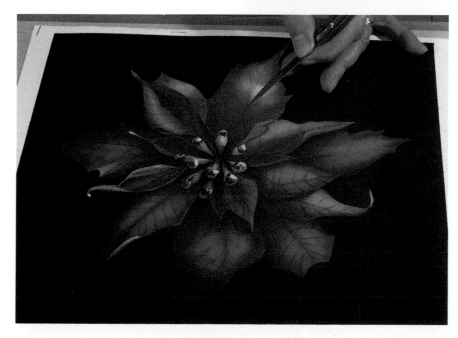

STEP THREE

Intensify by Glazing

Intensify the individual petals by adding additional glazes of color. While the paper is wet, use a knife to incise the surface, allowing the pigment to fall out of suspension into the incised line to form the veins in the petals. I use an ordinary kitchen paring knife, but any hard-edged tool will do, such as a craft knife, the back end of a Skyscraper brush, a nail file, a nail, a pin, etc.

Light Subject on a Dramatic Dark Background

Palette set up with
Golden Fluid
Acrylics for
Anemones & Roses.

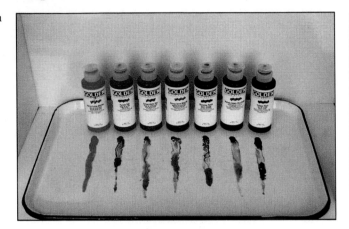

below

STEP ONE

Layer Washes

First paint three magenta anemones, layering wash over wash, using Quinacridone Magenta and Quinacridone Red. In order to more easily create the very dark center carpel—which was layered with Carbon Black and the adjacent colors—mask the stamens with masking fluid.

TIP: REMOVE EXCESS MASKING FLUID

When selecting a masking fluid, choose only masking fluid that has no color added. Keep a small bottle of dishwashing liquid detergent among your art supplies. Dip your brush into the detergent, making sure all the brush hairs are completely covered with the detergent, before dipping into the masking liquid. Clean the brush in clean water when the fluid begins to show signs of building up, and then start the whole process over again. Masking fluid allowed to dry in your brush is impossible to remove. For that matter, it is difficult or impossible to remove masking fluid allowed to remain on the paper longer than two or three weeks.

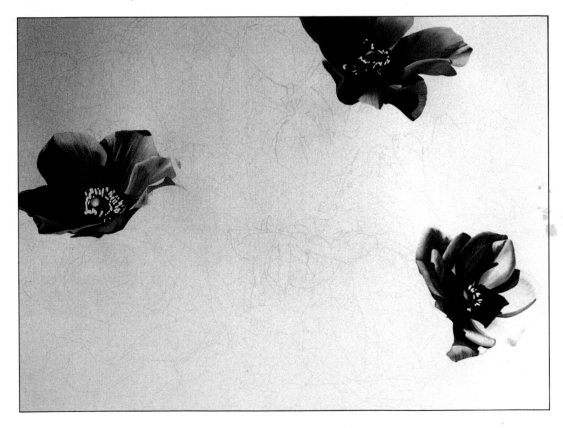

right

STEP TWO

Add Purple Hues

Paint the purple anemones in a similar way with Dioxazine Purple and Quinacridone Magenta.

below

STEP THREE

Paint One Petal at a Time

The pink roses are partially painted using Quinacridone Red and Pyrrole Red. When painting complex flowers, it is best to attack each petal individually, starting with a transparent underpainting of the petal shape using a wash of the lightest value. Then, use additional glazes to model the shape of the petal. Approach it as if each petal is a painting itself. The secret is in constantly comparing the petals to be certain the color is harmonious. If necessary, apply a unifying glaze over all the petals. The pink roses were finished by using thin transparent Phthalo Green glazes to show the parts of the petals in shadow.

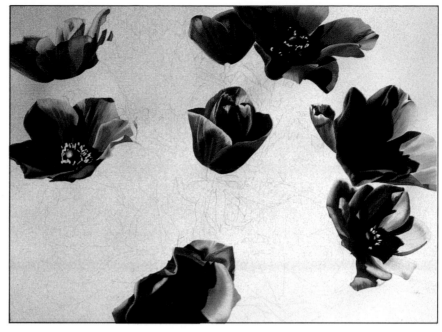

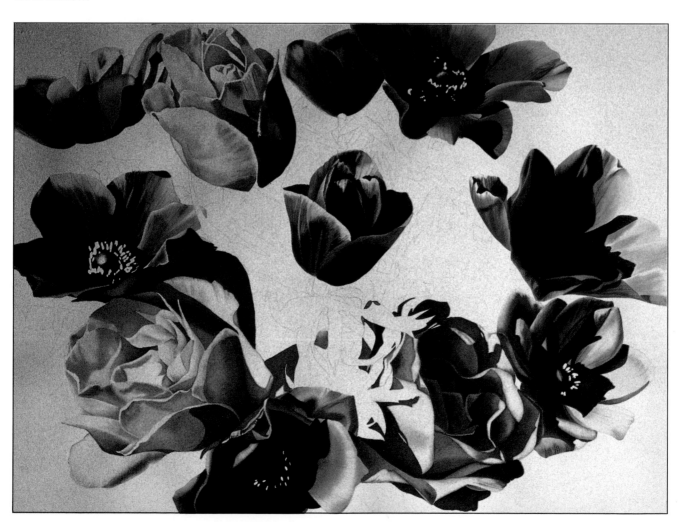

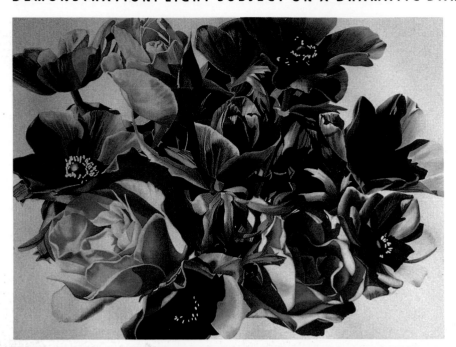

STEP FOUR

Use a Knife for the Veins

Add the center foliage using Phthalo Green, Hansa Yellow and Carbon Black. Use a kitchen knife to incise the veins in the foliage. Do this by painting the leaf and, while it is wet, cutting into the surface of the paper. This causes some of the pigment to fall out of suspension and into the incised lines.

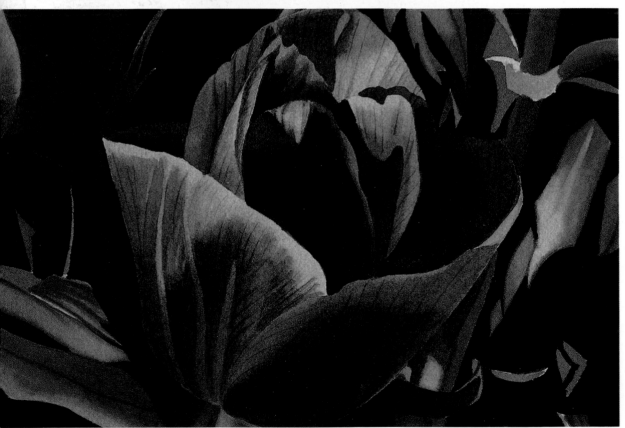

Detail of Center Purple Anemone
The veins in the center flower were created by incising the paper with a knife while the glaze was still wet. You can also see incised lines on the leaves.

TIP: Build Up Color
In order to achieve a dark area with acrylics in a water-color manner, it is necessary to build up the color by applying many glazes. If the paint is applied in a heavy layer, a shiny surface is produced, which is undesirable when painting in a transparent watercolor manner.

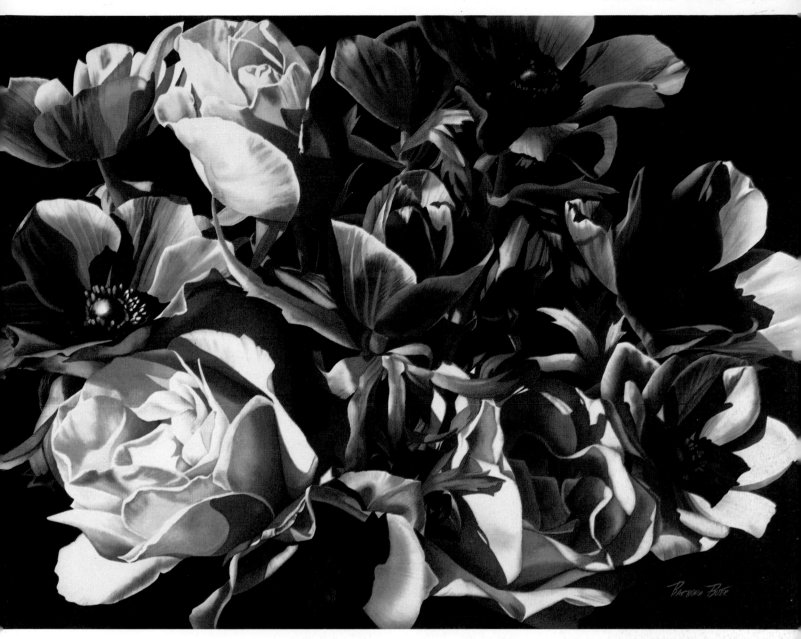

ANEMONES & ROSES *22"×30", Barbara Buer*

STEP FIVE

You can paint the dark background with a 1-inch flat white sable brush, applying numerous glazes of a thin mixture of Carbon Black and Dioxazine Purple.

TIP: Repair Mistakes

Although we all would love never to make mistakes, there are times when a judicious repair can save hours of work. To remove a build-up of acrylic paint, apply denatured alcohol with a brush and wipe up the softened paint with a paper towel. This will not remove the stain from the paper, but will reduce it greatly. In order to repaint such an area in a watercolor manner, apply thin glazes of Golden *Mat* Acrylic Titanium White until the stain is obliterated. The matte finish allows future repair glazes to adhere better than if regular glossy acrylic is used to bring the paper back to white. If your paper is not as white as the Titanium White acrylic, you may want to add a drop of color to the Titanium White in order to more closely match the color of the paper. For instance, using Arches paper, I add a touch of Yellow Oxide to the Titanium White because the Arches paper is a much warmer color than the Titanium White acrylic paint.

Use Titanium White as a Mask

To keep a pattern under layers of acrylic glazes, use Titanium White. Here, Titanium White was painted over a tracing of a stencil. Using a 1-inch flat white sable brush, paint a wash over the entire piece of paper. Dry it and put a strip of masking tape over the first inch at the top of the paper. Apply another glaze over the rest of the paper. Once dry, add another inch of masking tape and apply another glaze over the rest of the paper. Continue this process until you reach the bottom of the paper. The Titanium White acts as a partial mask, but is never entirely obliterated, even under ten glazes. I often use this technique when painting background draperies, such as in the paintings here.

below

ISLAND STILL LIFE
22"×30"
Barbara Buer

I used Titanium White as a mask in the dark background drapery to paint a simple pattern that shows under both the highlighted part of the drape and the part in shadow.

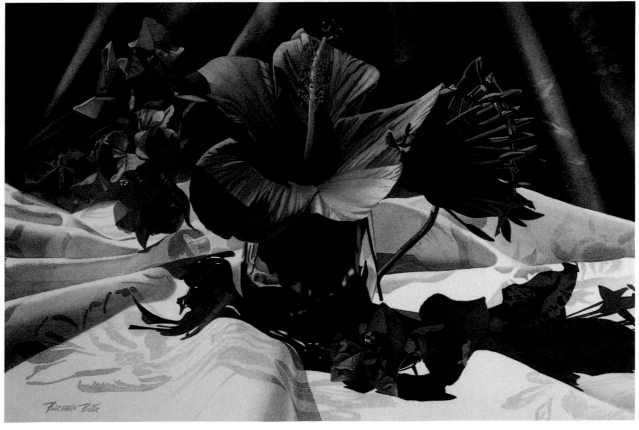

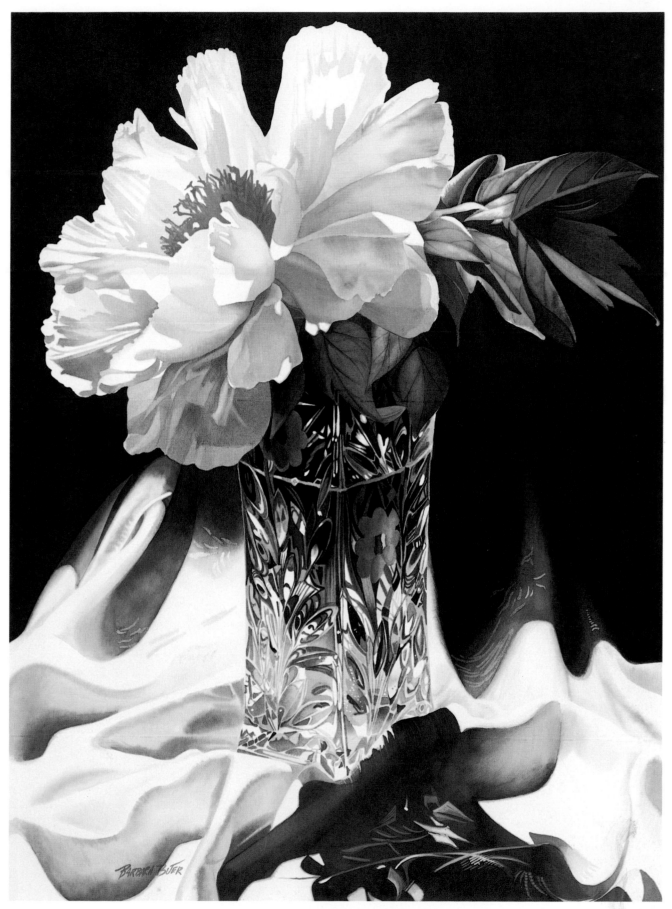

WHITE PEONY *22"×30", Barbara Buer*

Paint a Dark Subject on a Light Background

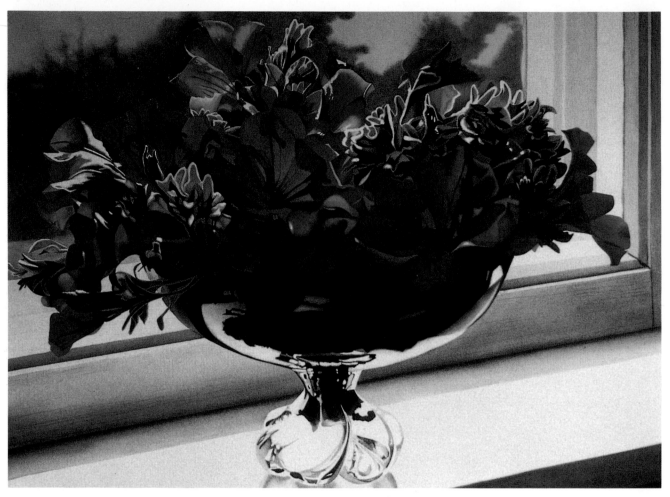

MAGENTA PETUNIAS
22" × 30"
Barbara Buer

Underpainting is extremely helpful in defining the complex shapes caused by closely arranged flowers. Rather than painting one thick coat, layer many thin layers of acrylic of a watercolor consistency. Thin glazes of Golden Fluid Acrylics are easily overpainted because of their permanence. Overpainting with watercolors disturbs underlying washes and results in muddy passages.

Build color by applying many thinned fluid acrylic glazes. For *Magenta Petunias*, I used Quinacridone Magenta, Pyrrole Red, Quinacridone Red, Phthalo Green and Carbon Black.

Use masking fluid to mask out areas of reflected light on the bottom of the vase as well as the petals and stems hanging over the vase. For this painting, I applied numerous glazes of Dioxazine Purple and Carbon Black with a 1-inch white sable flat brush.

After removing the masking, dampen the reflected light areas and soften the edges. I used Dioxazine Purple and Carbon Black again. For the window frame, I used Burnt Umber and Carbon Black with a touch of Dioxazine Purple.

I painted the foot of the dish with the surrounding colors, and washed in a light underpainting to suggest the background foliage outside the window. The darker background window foliage was painted with numerous glazes of Phthalo Green, Carbon Black and Dioxazine Purple, then glazed over with Iridescent Silver to soften the deep color and suggest a window glass.

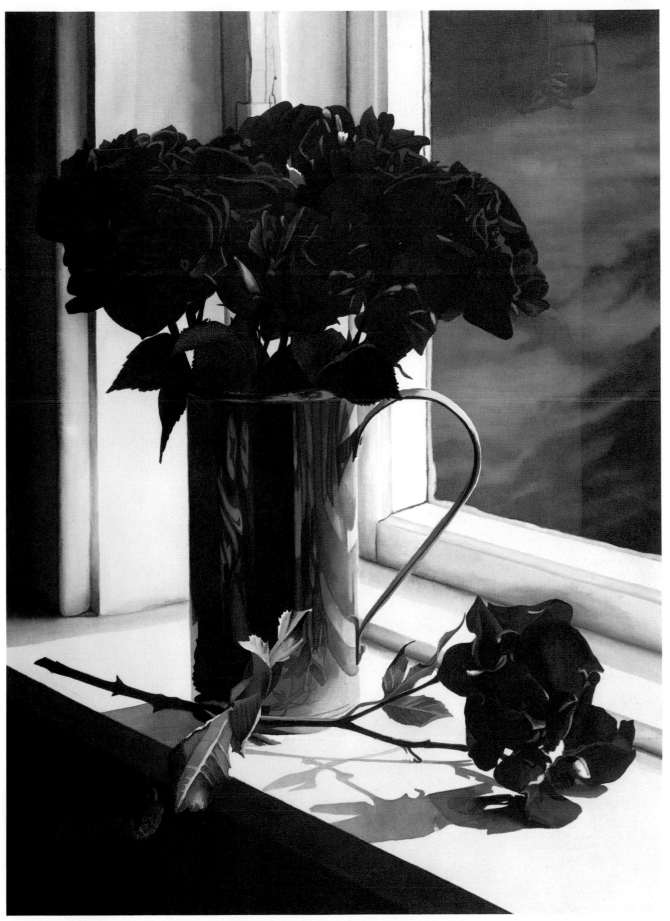

RED ROSES, BRASS CONTAINER *30" × 22", Barbara Buer*

Buer Gallery

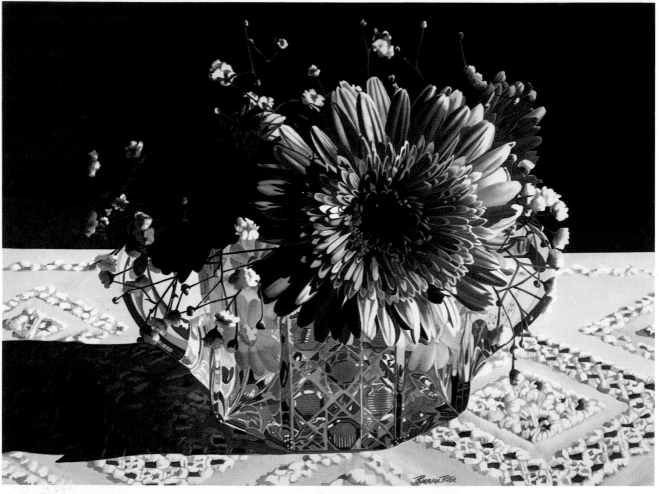

GERBERA DAISY
22"×30"
Barbara Buer

WHITE BLEEDING HEARTS
22"×30"
Barbara Buer

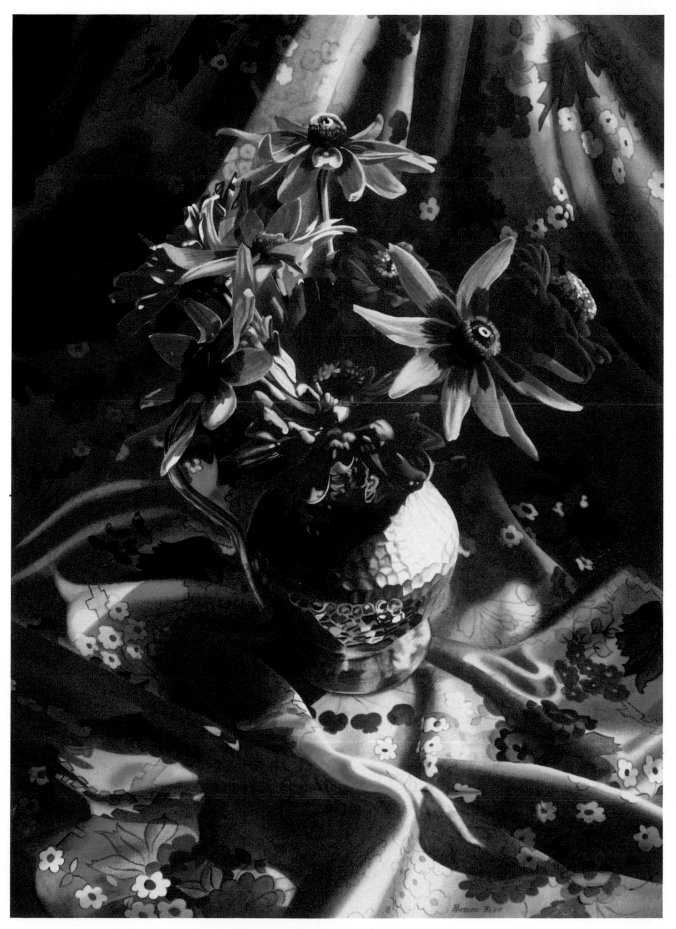

RED ALL OVER *48"×36", Barbara Buer*

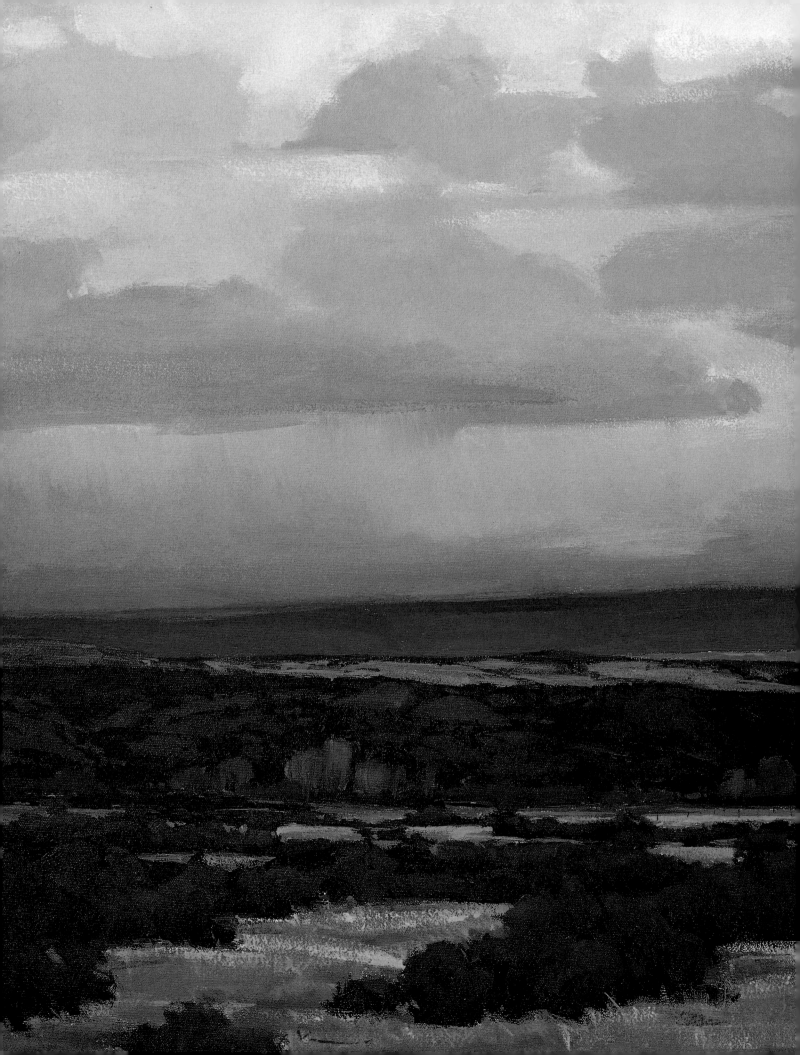

CHAPTER FOUR

Pulsating Color With Buttery Imposto Strokes

William Hook paints breathtaking vistas and lively flowers

William Hook spent sixteen years in advertising design and illustration before entering the arena of landscape painting. Because of the quick drying time, acrylics were the medium of necessity for illustrations that were to be reproduced hours after the painting was completed. For fine art, acrylics have been his medium of choice for over thirty years. During this time, Hook has explored most styles of objective representational art. Large canvasses with ''Motherwellish'' brushstrokes preceded expressionistic still lifes that contain heavy impasto layering.

Today, his paintings are a combination of all the techniques he has employed over the past thirty years. He sees no need to always paint with the same style when the medium of acrylic paint will handle anything he wants to create. Every single painting Hook makes has a multitude of paint applications, from thick buttery strokes to thin watery paint, soft blended areas to crisp geometric flat areas.

Hook paints representational subjects while developing a strong abstract design marked by bold color and brushwork.

NEW MEXICO PALETTE
30"×40"
William Hook

William Hook's Basic Techniques

1 First, he sketches out the scene to be painted directly on the primed support with a water soluble pastel pencil. This sketch indicates a basic composition and position of subjects so the paint can be applied and blended on the canvas in a quick manner. Using a spray bottle to mist both palette and support, he prolongs the liquidity of paint to enhance color blending on the support.

2 In order to get two painted subjects to blend harmoniously, he avoids letting the paint dry with any thickness. If the paint is applied too liberally, overpainting a house with a bush, for example, would leave an indication of the house's porch under the paint of the bush.

3 The background of a painting is typically in the upper half of a broad landscape. Hook uses negative painting in this area to shape the positive subjects, such as trees or buildings, by stroking out parts of that blocked-in subject and sculpting its shape in an overall effort to control the composition of the background.

4 After a painting is basically blocked in, Hook often utilizes overpainting to tie all of the small individual sections together after the paint has dried. He achieves an impasto effect by adding thicker paint over dried paint. Hook tries to create a unified look with the impasto, and believes the viewer should never have a clue as to the mechanical process used to make a painting work.

This photo indicates the studio setup and the viewer I use for photographic reference. I utilize ambient north light by which to paint.

I generally put a blob of paint about the size of a quarter on the palette. The color in the subject that I am painting will dictate how much of a pigment will be pressed out of the tube.

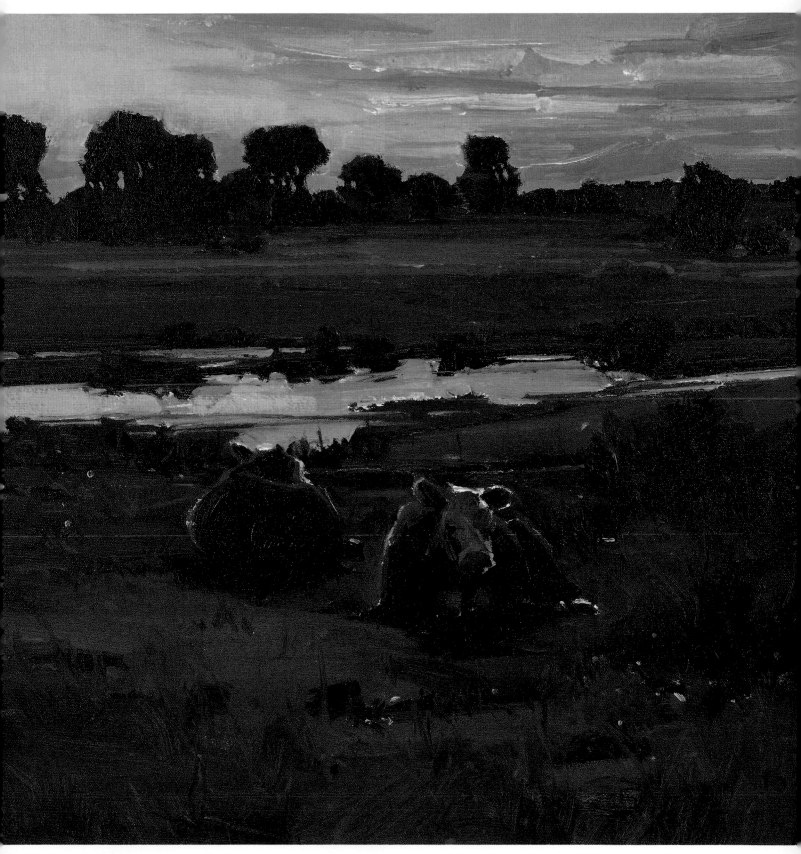

MOO MOO
20" × 20"
William Hook

Carve Out a Snow Scene

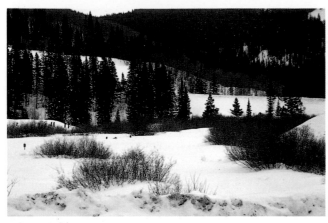

The photograph used for reference.

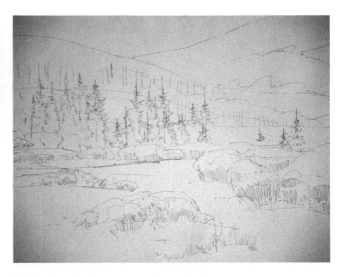

above

STEP ONE

Rough Sketch

Sketch out the subject to give yourself reference points on the canvas. This enables you to avoid any guesswork that might slow the painting process. Acrylic paint dries quickly and I like to work quickly, blending paint on the canvas while the paint is completely wet.

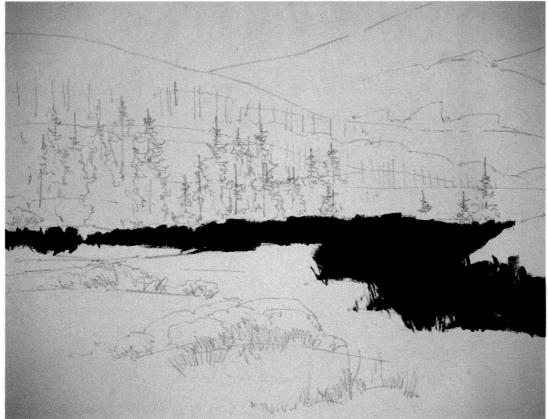

STEP TWO

Paint the Midground

Typically, I recommend starting a painting in the midground. Blend as much of the blocked-in subjects as you can. If you do not overpaint the entire canvas, much of the blended paint will be visible in the finished work. The colors of the willows are mixed from Dioxazine Purple and Naphthol Crimson. Burnt Sienna is used to tone down area while Cadmium Red Light is used to highlight areas.

STEP THREE

Block In Quickly

The sections I have blocked in are of similar hues. To paint the evergreens, mix an ample quantity of wet green colors on the palette. Paint quickly, finishing the evergreen block-in before the paint dries on the palette. The same is true of the red willow pigments and the more neutral colors of leafless aspen trees.

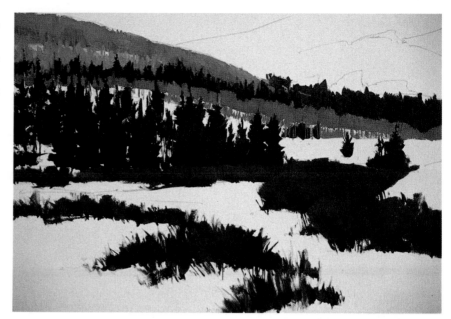

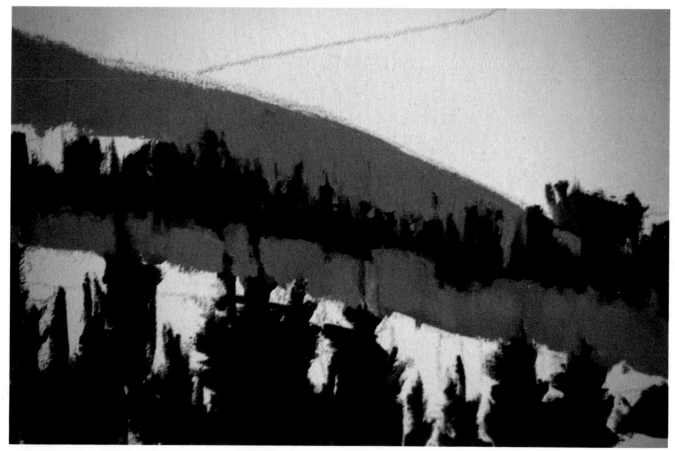

Detail

This detail shows how two painted subjects (aspen trees and evergreen trees) are blocked in next to one another. By using a larger brush (no. 10 synthetic bright), you can apply paint in a fairly quick manner. This helps blend larger areas and inhibits any desire you might have to prematurely add detail to the painting. The evergreens are made from Hooker's Green, Phthalocyanine Green, Burnt Sienna, Permanent Green Light, Yellow Oxide and Ultramarine Blue. The aspen trees are painted from white, Yellow Oxide, Medium Magenta and Permanent Green Light.

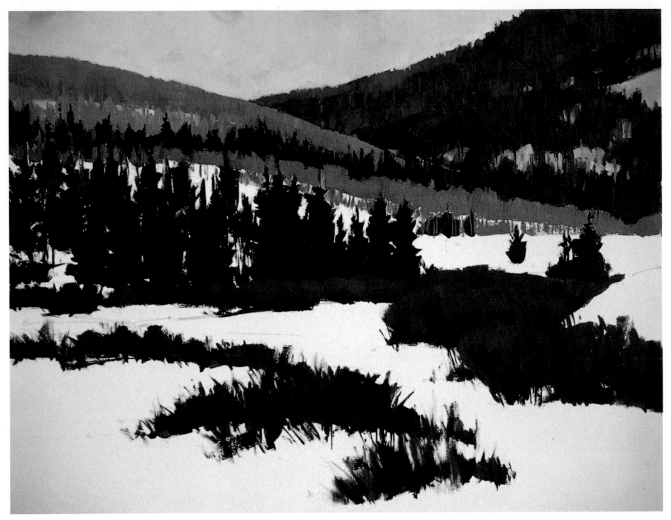

STEP FOUR

Achieve Spontaneity

In a snow scene like this, allow the white of the canvas to simulate the snow so you can continue to paint the distant ground. Spray the section that will become distant trees with a fine mist of water to facilitate the application of paint over a larger area. The spray also helps the pigment stay wet on the canvas while you add detail by blending hues and brushing on paint in the vertical direction of the trees. The spontaneity and directness achieved during this process will remain in the finished painting.

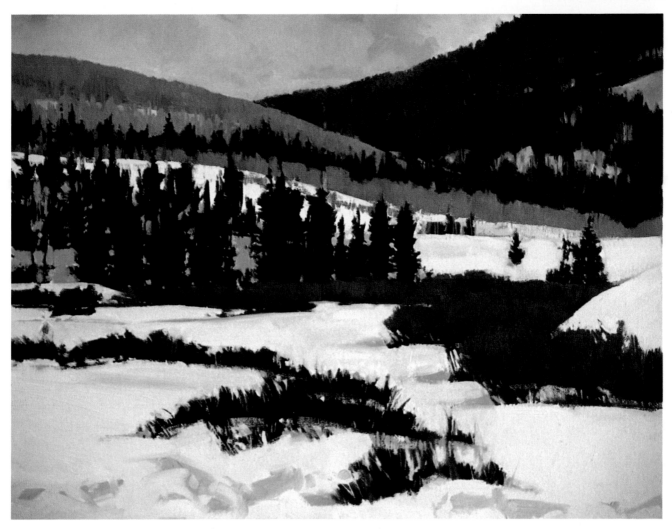

STEP FIVE

Add Snow

Now paint the white of the canvas with a very similar hue. Spray the entire canvas with a fine water mist before brushing in the snow. The snow will help shape and design the trees and willows. While the paint is wet, add detail to the snow by mixing in shadow color. The snow color is slightly grayed with Medium Magenta and Permanent Green Light. This creates a neutral value that will allow bright highlight to be added in contrast at a later time. Paint the sky with a bit of blue showing through. This blue will be an undercolor only and will show through in the finished painting.

TIP: Painting Shadow
The secret to painting shadow is in the amount of bounced light you see in the shadow itself. A dark, contrasting photo will never work. I study the light at the time I photograph and recall that mental note when painting.

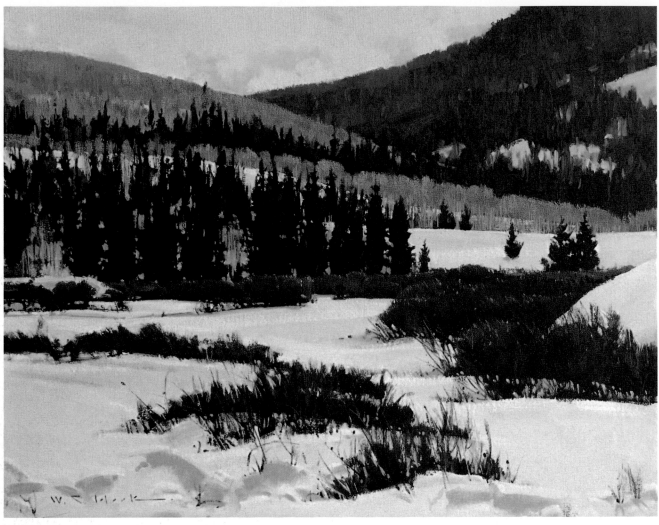

WINTER PATTERNS
24" × 30"
William Hook

STEP SIX

Finish

Until this point, you have used mainly layering and dry brush techniques. Now, the sky changes from the previous step due to the layering of lighter valued pigment. By doing this, you are able to change the mood of the entire painting. More highlights and details are added. The finished painting is a combination of techniques; however, impasto is achieved through light strokes of paint with no additives.

TIP: Dry Brush Details

Dry brush details are finishing touches that will make the painting come together. A contrasting light pigment works best in the sunlit areas, while darker values are natural in the shadowed areas.

Detail
I have utilized layering for the painting of negative space between the evergreen trees. In the shadow areas, Medium Magenta and Ultramarine Blue are mixed with white. No water is used. This allows single brushstrokes to diffuse, or soften, the edges of the subjects being overpainted.

Detail
Following the painting of the negative areas, use the edge and corner of a no. 8 bright brush to render the narrow trunks of trees. Overpaint these trunks on either side in order to give an irregular look of a tree, and not simply a brushstroke.

Technical Tips

Load Your Brush With Paint
A no. 8 or 10 bright brush loaded with paint acts almost like a palette knife. The stiff synthetic bristles keep the paint on the outer sides of the brush and not on the inside next to the ferrule. A single stroke can be thick with paint, or it can be very wide if pressure makes the entire brush (from the ferrule to the tip) touch the support.

Use a Light Touch
Painting in a light fashion means that the brush is not given any more pressure than necessary in order to let the paint adhere to the canvas. The canvas color will show through where the paint does not touch the lower places of a canvas surface. I also refer to this technique as "dry brush."

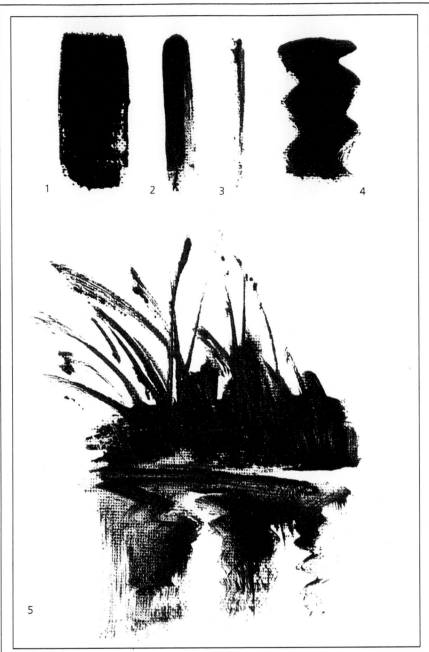

A Variety of Strokes From One Brush
Top
1. Make the first stroke with the entire broad side of a bright brush. Apply a medium amount of pressure in order to achieve an inch-wide stroke.
2. Make the second stroke with the side of a bright brush. This stroke is one quarter of an inch wide and is about the same as using a no. 1 bright.
3. The third stroke utilizes the broad edge of the same bright brush. This is representative of a quick vertical stroke that requires very little pressure when the corner of the brush is stroked over the canvas surface.
4. The fourth stroke takes advantage of the broad edge of the brush when a vertical squiggle is desired. Make it the same way as you did the first stroke, except the back-and-forth motion varies the thickness of this stroke.
 Above
5. All of these strokes are used in the silhouette of grasses on a stream bank.

Understanding Negative Painting

1. Paint the rough shape of evergreen trees in vertical strokes. Blend the tree color.

2. Rough-in a cabin over the evergreens. This is a positive paint application.

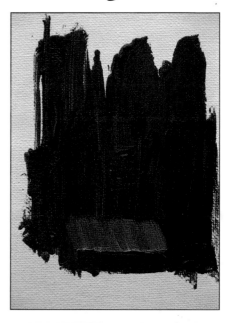

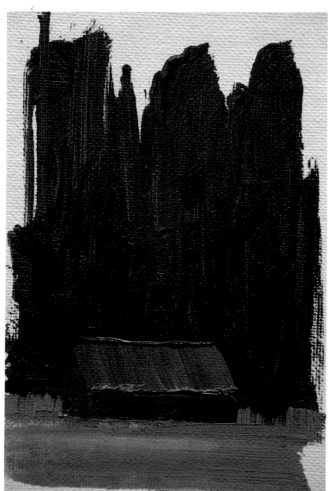

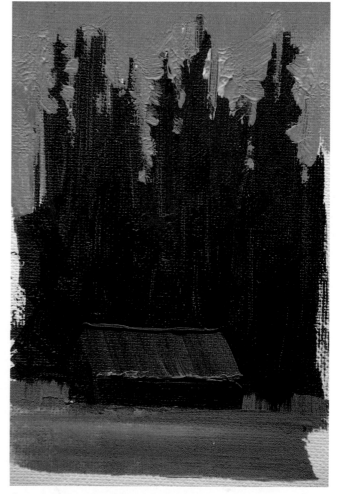

3. Paint the yellowish foreground around the cabin and the evergreen pigment. This defines and clarifies the shape of the cabin and is negative painting.

4. Background sky (the negative) defines the shape of the trees (the positive). The sky is blended while the paint is wet.

Create Unexpected Edges With Negative Painting

This photograph is the reference for this demonstration.

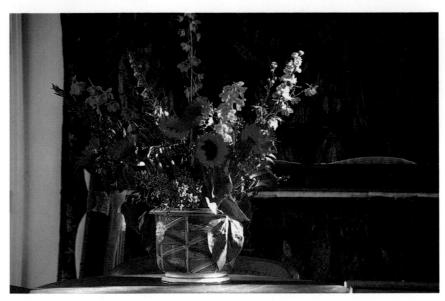

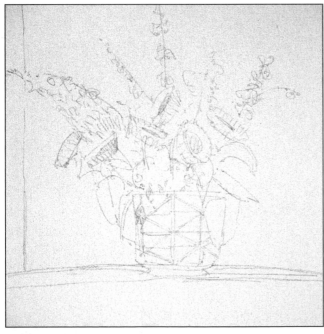

STEP ONE

Sketch

My process for developing a still life is the same as for a landscape—I sketch it first.

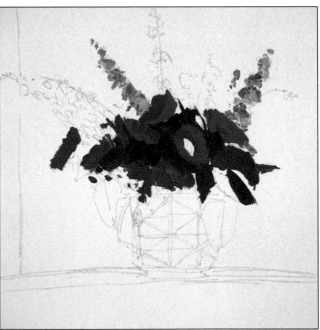

STEP TWO

Begin With Lighter Flowers

Sunflowers are the primary subject in this scene, so begin with them. Thin and paint Cadmium Yellow Medium in a way to let translucency work for you. Light will pass through the thinned pigment and bounce back to create the effect of brightness. Do not use an acrylic medium glaze or else you will end up with the glaze in the rest of the painting. (The glazing creates a gloss surface that I do not like.)

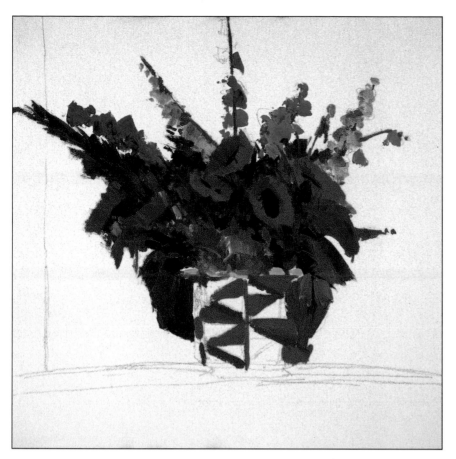

STEP THREE

Block In Darker Colors
Block in the darker colors after the light colors in order to help shape the flowers themselves. Use Permanent Green Light, Phthalocyanine Green, Yellow Oxide and Cadmium Yellow Medium to make the foliage.

below
Detail
Much of the color mixing is done on the canvas. Rely on wet paint to promote natural results. By "natural," I mean that foliage has so much detail I prefer to see the pigments swirl together and blend freely without brushing out such spontaneous happenings. Experience has turned what was once "unexpected luck" into controlled and expected results.

STEP FOUR

Complete the Still Life

These details will demonstrate the process I call "negative painting." It is my belief that the viewer responds to the unexpected with more excitement than when the expected is provided. This is the reason why I paint in the background after the foreground.

Detail

This detail shows how the vase was painted. To create consistency throughout the painting, the brushwork is similar to that in the flowers. Paint quickly, to blend wet paint on the support. The shapes in the vase utilize negative painting just as in the background. Define narrow bands of color by painting in the larger triangular shapes afterward. Highlight the natural blending and swirls created on the canvas with white. Pick obvious spots where the reflections are brightest and add a quick stroke of white with the corner of the no. 8 bright.

STEP FIVE

Detail: The light source is to the right of the scene, so paint in the background color (purple and Naphthol Crimson) up to the edge of the flowers' left side. Leave parts of the white canvas showing on the right side of the flowers, rather than using predictable brushstrokes to add highlights. The brushstrokes remain obvious in the background. The ambiguity of the background is enhanced by this technique, which is also harmonious with the brushwork in the flowers and vase. Negative painting allows you to make very quick and deliberate strokes leaving the viewer unaware that one brush was used to paint the entire painting.

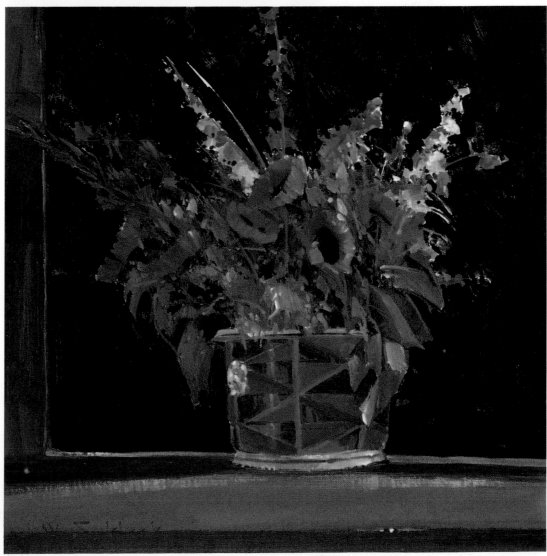

SOME FLOWERS *18" × 18", William Hook*

Working Quickly and Wet

This photograph was used for the composition and subject of the painting. It is too dark for the foreground detail, but it is the proper exposure for the distant ground.

This photograph was used for color and light in the foreground area of the painting. The distant ground is overexposed and not usable for painting reference. I use a camera as a sketching tool. The use of more than one reference photograph is not unusual because of the limits of photography. It is necessary to record as much visual information as possible before heading back to the studio.

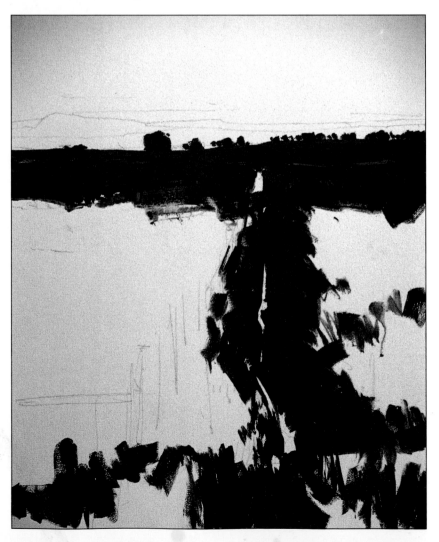

STEP ONE

Work Quickly

I will paint this scene in a very direct and quick manner. After doing a quick pencil sketch to establish composition, I mixed a good deal of Hooker's Green with Phthalocyanine Green and Ultramarine Blue for the darkest area of the painting. By spraying the canvas with water before painting, you should be able to lay down this area of paint in about three minutes. The paint is wet and thick, and can be applied with a no. 10 bright. Blend lighter color into the dark color on the canvas without thoroughly mixing the lighter colors so that some raw color will remain.

STEP TWO

Add Detail

You should arrive at this stage of the painting in about twenty minutes. Mist the canvas every ten minutes in order to keep the paint wet and the blending process possible. Add all of the detail with the same no. 10 brush by using the thin flat edges or the sharp corners. Make the fence posts from Dioxazine Purple and Burnt Sienna. Add these elements on top of the green paint while that paint is still wet. I have left the stream unpainted because I want the white of the support to bounce light back through the light paint I will apply later.

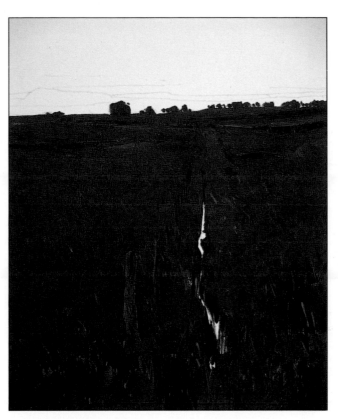

STEP THREE

Overpaint

Allow the paint to dry so that you can overpaint areas without polluting the lighter colors you are about to add. No misting is necessary at this point. The canvas should be dry so that the paint can soften the edges of the trees in the midground, then mist the surface of the canvas where the sky is being painted. Paint a light mixture of Cadmium Yellow Medium and white in most unclouded areas of the sky. Add the cloud masses to the canvas while the yellow paint is still wet using Ultramarine Blue, Yellow Oxide and white. The value difference between clouds with the light source behind them and the sky itself is minimal.

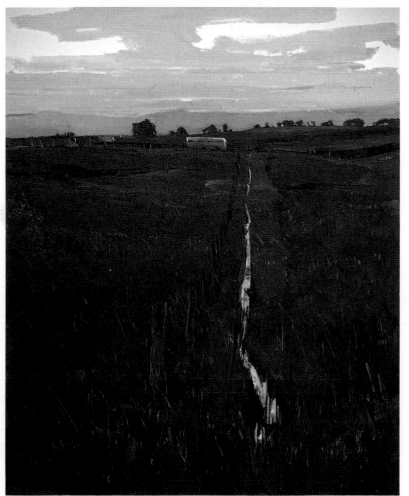

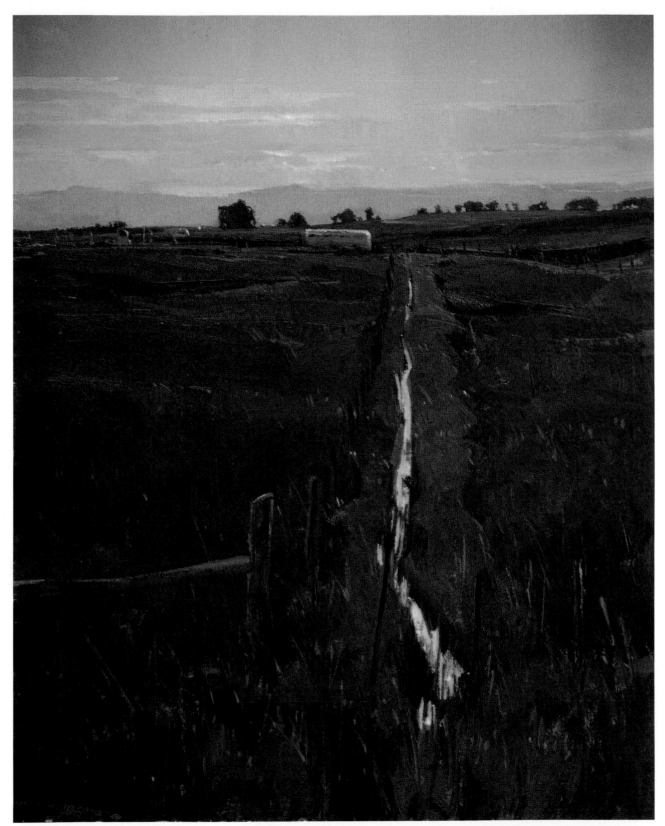

Finish

I completed the finished painting in approximately three hours. The greatest amount of time was spent on the smaller part of the painting—probably about two hours. I have done very little overpainting in this work. My intention from the start was to utilize wet and spontaneous strokes to quickly create a medium-size painting in a manner that a small painting might be made. I have found that larger paintings usually influence even the very best painters to become slow in their work.

FENCELINE
30" × 24"
William Hook

Details
The distant mountains have the same light source as do the trailer subjects in the field of the midground. This similarity allows the shadow and highlight areas to be made consistently from the same color mixes. The yellow highlights appear on the top edges of the horse trailers and in the fence posts. The purple and blue shadow colors are very close to the mountain silhouettes.

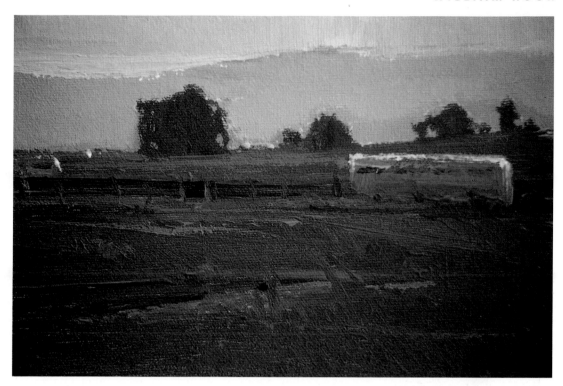

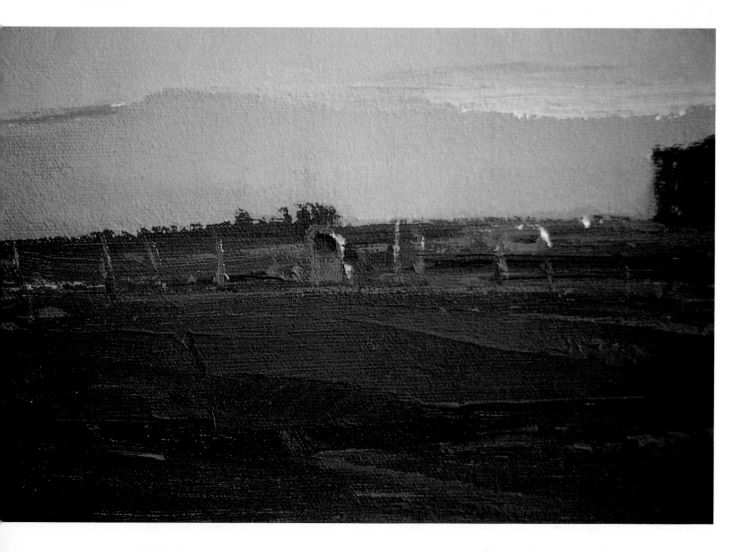

Hook Gallery

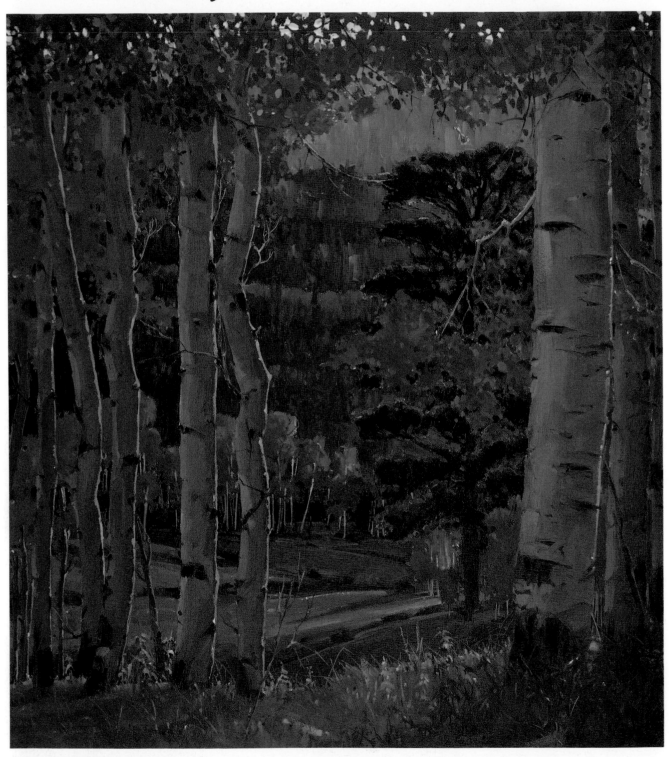

EDGE OF AUTUMN
40" × 36"
William Hook

GREENGROVE
24" × 24"
William Hook

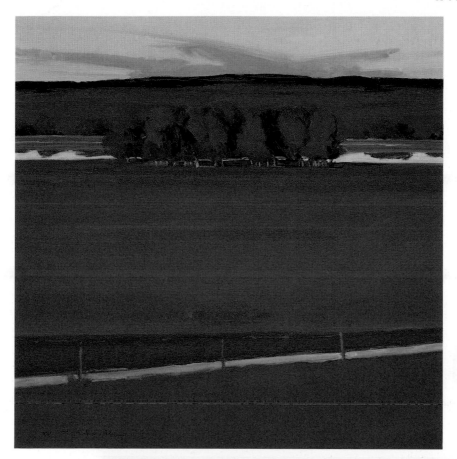

STILL LIFE
12" × 12"
William Hook

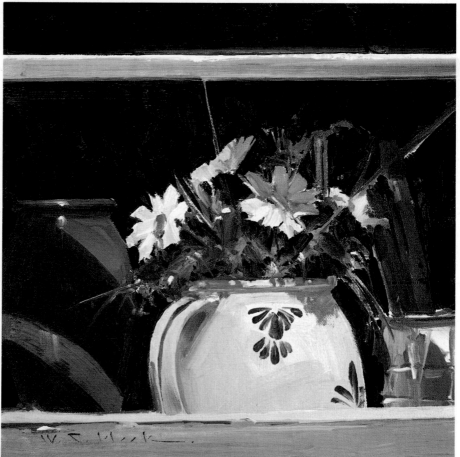

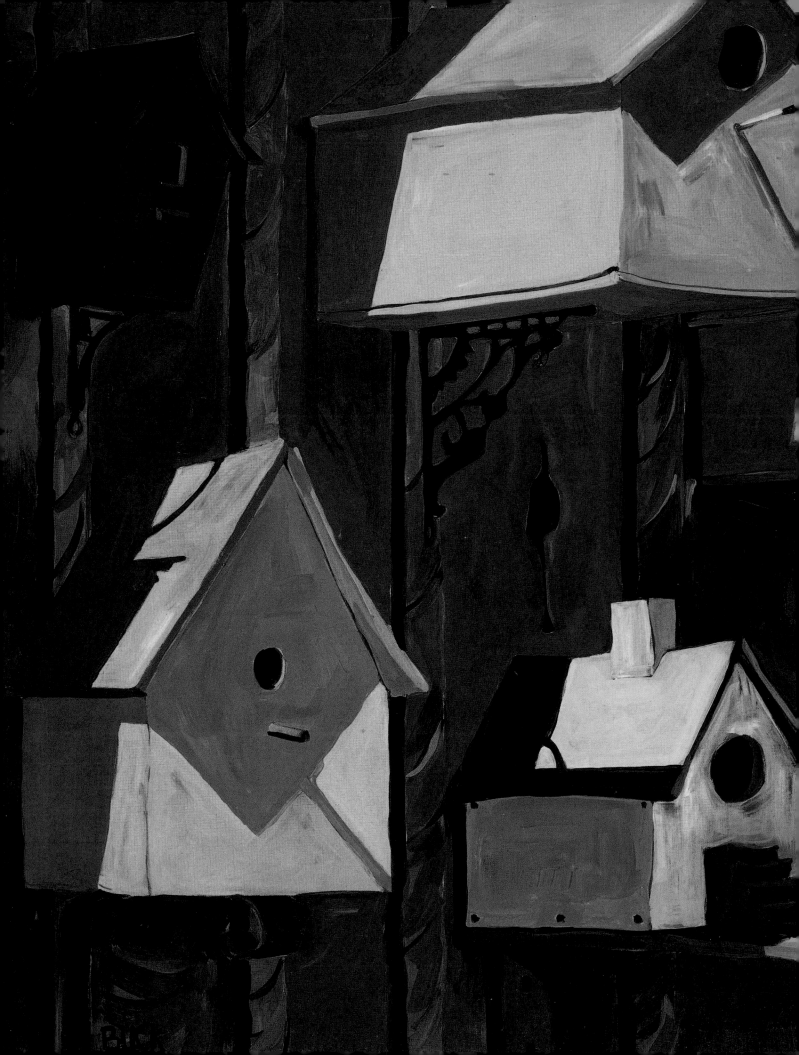

Careful Planning Produces Lively Results

Lisa Buck-Goldstein paints contemporary still lifes with vibrant patterns

Painting has always been an important part of Lisa Buck-Goldstein's life. As far back as she can remember, she has had a brush in her hand. She still cherishes the first set of watercolors given to her by her father over thirty-five years ago. More recently, acrylic painting has become her passion. It is not duplicating a simple snow scene or the neighbor's cat that compels her to paint, but rather the opportunity to learn and to explore the beautiful potentials of the paint quality.

She is a studio painter. Her subjects are busy urban patterns or brilliant summer gardens, filled with colorful rhythms and patterns of light. She captures these with a 35mm camera and a telephoto lens, looking for subjects that are repetitive, similar subjects appearing in multiples—individual shapes merging together to create a flat, abstract pattern, held together by dark negative shapes and brilliant colors.

After a day in the garden, the city or at the local recycling center, she reviews the 4″ × 6″ color prints and selects her subjects, sometimes using two or more reference photos to create a final design.

JILLY'S BIRDHOUSES
28″ × 36″, Lisa Buck-Goldstein

Lisa Buck-Goldstein's Technique

Here are materials and techniques that Lisa Buck-Goldstein has found work consistently well for her.

Materials List
- no. 2B pencils, sharpened
- Draftsman's eraser horse hair brush
- white Staedtler Mars plastic eraser
- 3-inch butcher's tape (gummed Kraft tape)
- steel ruler (24-inch)
- tissue tracing paper
- 1-inch white paper tape
- 140-lb. hot-press Arches watercolor paper
- red felt-tip pen
- Scepter Gold synthetic watercolor brushes
- no. 4, no. 5, and no. 6 rounds (short handled)
- ¼", ½", ¾" and 1-inch flats
- acrylic flow improver by Winsor & Newton
- acrylic gloss gel med by Winsor & Newton or Liquitex
- ½-inch Homosote board, 19" × 26". This will hold a ½-inch sheet of paper (15-inch × 22-inch) beautifully.
- palette: white Plexiglass, 12" × 14"
- two large jars for water
- small ½-pint container for acrylic flow improver solution
- paper towels

Acrylic Paints
All colors are by Winsor & Newton. I lay out my colors from lights to darks, placing my three primary colors in close proximity to each other. The colors are listed in the order they appear on my palette.
- Cadmium Yellow Light
- Naples Yellow
- Yellow Ochre
- Medium Magenta
- Cerulean Blue
- Quinacridone Violet
- Permanent Alizarin Crimson
- Dioxazine Purple
- Ultramarine Blue
- Cobalt Blue
- Phthalo Blue
- Phthalo Green
- Olive Green
- Raw Umber
- Burnt Umber
- Mars Black
- Titanium White*

*Two portions are squeezed out separately. One portion is used for mixing tints; the other, for mixing clean whites.

Mounting Watercolor Paper for Acrylic Painting

Mount the dry paper onto a ridged board of Homosote. Homosote is ½"-thick, compressed cardboard—light enough to handle, rigid enough to support the paper for hours of work. I have two sizes, one for my full sheet, 24" × 36", and a smaller piece, 19" × 26", for half-sheets. Homosote is available at your local lumberyard.

1. Place the dry paper centered on the board, as straight as possible. Draw a pencil margin on all sides about ⅝" in from the edge of the paper.
2. Tape it to the board using 3-inch butcher's tape, moistened by pulling it through a container filled with lukewarm water. Tear the tape in full lengths approximately 3 inches longer than the width of the board.
3. Lay the tape about ¼" over the edge of the watercolor paper, allowing approximately ⅜" between the pencil margin and the edge of the tape. Fold over excess tape onto the back of the Homosote, leaving the front clean and even.
4. Using a clean, dry paper towel, wipe the excess moisture off the butcher's tape smoothing it as you go.
5. When this has dried, take 1-inch white paper tape, using full lengths longer than the board's width for the mask that will create the clean edges of the painting.
6. Carefully line up the tape along the pencil margin, pulling it tight so it lies flat and smooth on the paper, its edges follow the outline of the painting and it overlaps the edges of the brown butcher's tape.

Use Paper as a Painting Surface
I use paper for painting my acrylics instead of canvas or canvas board for several reasons.
- I paint in both transparent watercolors and opaque acrylics. Using the same paper means fewer materials and consistency for framing using the same mats and frames. This is an advantage when preparing for an exhibition.
- It's easier to store unframed works in a large flat file.
- When entering an Aqua Media juried exhibition, I am not limited to which pieces I can enter, since my works on paper, framed and under glass, can be considered.
- Working on paper allows me to develop strong pencil drawings, thereby enabling me to solve many problems before I start painting.
- Working on paper gives the painting a smooth, clean finish.

Painting Nature's Patterns

These two photos were taken on the shoreline of a local pond. The beautiful, soft pastel colors of the inverted leaves first drew me to this subject.

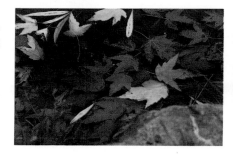 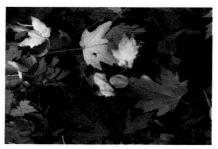

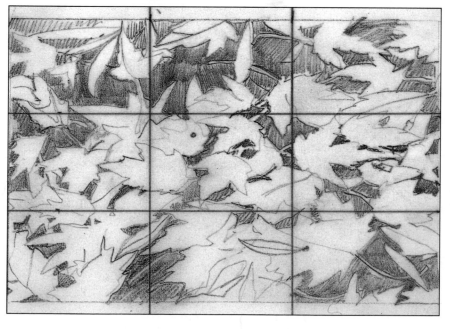

STEP ONE

Make a Thumbnail Sketch

Using a sharp no. 2B pencil and tracing paper, trace the photo on a studio light box, reworking the tracing several times if necessary. A sharp pencil gives better control and cleaner lines. Trace the thumbnail using a continuous contour line, rarely breaking the line by taking your pencil off the paper. In this way your hand can feel and familiarize itself with the image. Add and subtract details until you are happy with the design.

STEP TWO

Draw a Grid

Using a red felt-tip pen, draw a simple grid over the sketch, measuring and marking off the height and the width of the sketch in thirds, dividing the drawing into nine equal sections. If the drawing is complex, divide these blocks again to make a 6×6 grid.

The sketch is now ready to be enlarged and transferred to watercolor paper. Trim the thumbnail sketch and mount it to a piece of bristol board so it has a white background and is more durable for handling. Draw a diagonal line through the thumbnail.

STEP THREE

Transfer the Drawing

On Arches watercolor paper, draw the upper left and top edge 1-inch margin using a sharp no. 2B pencil and T-square. Line up the upper left corner of the sketch to the upper left corner of your paper using the drawn margins as a guide. With a ruler placed on the diagonal, find the intersecting point on the lower right-hand corner of the painting. Now the drawing can be enlarged to its desired dimensions. Allow for a 1-inch border on all sides. Once the outer edge is established the grid can be marked out, a guide for the finished drawing.

STEP FOUR

Enlarge the Final Drawing

Using the thumbnail sketch, rough in the subject using the simplified shapes in the grid as a guide. Using three or four blocks in the grid at a time, the drawing slowly begins to appear. Make sure there is a good balance between the negative background shapes and the positive subjects. Don't be afraid to make changes. Lines can be corrected with a white plastic eraser. An average drawing takes me six hours to complete.

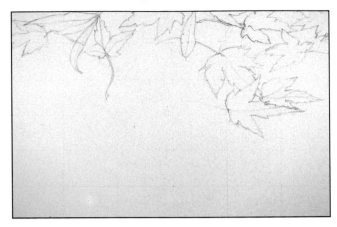

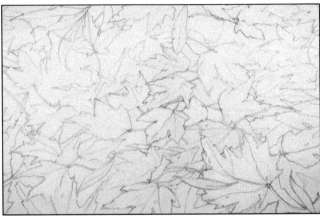

STEP FIVE

Apply the Initial Glaze

Wash the upper left in Cerulean and Cobalt Blue, the foreground in Medium Magenta, and the bright, sunny band of Yellow Ochre diagonally through the middle. This sets out the overall color scheme of the lights.

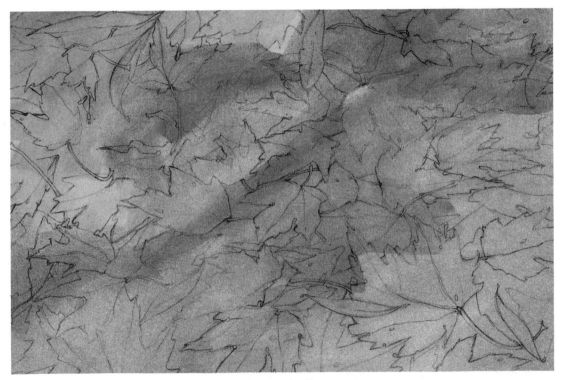

STEP SIX

Paint Darks for Negative Spaces

The dark background is the foundation for the painting. Notice how transparent this first layer is. By painting the darks first, you can further correct the drawing with your brush.

STEP SEVEN

Add Opaque Color

Detail of left half: For a warm, earthy palette, add Raw Umber, Cadmium Red Light, Burnt Umber and Olive Green. As you apply these colors you can create additional leaves through negative painting. These shapes were created with darker opaque overpainting, still allowing the lighter value study to show through.

STEP EIGHT

Paint Darks Thin, Brights Opaque

Apply the darker areas in thin, translucent colors to help them recede into the background. Paint the brights in a heavier consistency to make them more opaque, bringing them to the foreground. To achieve this impasto texture, mix the lighter tints and whites with acrylic gel medium. This gives the paint more body while keeping it soft and pliable. As the painting nears completion, step back and review the work. Check for color balance, noting any problems and areas of poor paint quality.

STEP NINE

Remove Your Painting From the Board

When the painting is finished, remove the white paper tape. This will leave a clean, white margin framing the entire painting. To remove the finished painting from the Homosote, I recommend using an X-Acto knife with a sharp no. 11 blade and a straight edge. (I prefer a cork-backed 24-inch steel ruler: The cork prevents the ruler from slipping and the steel cannot be cut or nicked.) Carefully line up the ruler against the outer edge of the white margin and the brown tape. Hold your breath while cutting to make your cuts steadier and straighter. When all four sides are properly cut, the painting should just pop out.

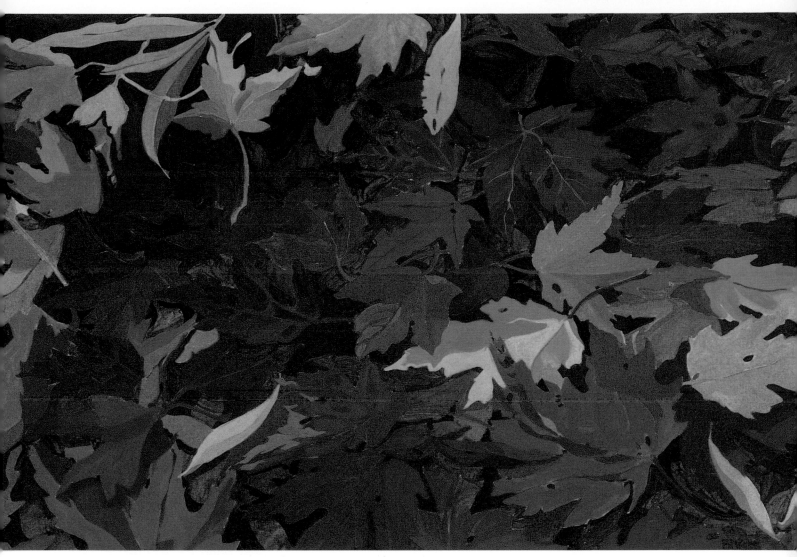

Because this painting does not have a
strong light source, it becomes a work of
colorful interlocking patterns and
shapes instead of a painting of light.

AUTUMN LEAVES
13″×20″
Lisa Buck-Goldstein

TIP: Drawing COMPLEX SUBJECTS
A helpful hint for drawing complex subjects is to look not
at the subject, but at the negative space—or background
shapes—the subject creates.

A ''Recyclable'' Demonstration

This photo was taken at the local recycling center. The Pepsi bottle is dominant and is a very unpleasant shape.

I corrected this by crushing the bottle's side in my drawing, giving the shape more movement and sensuality.

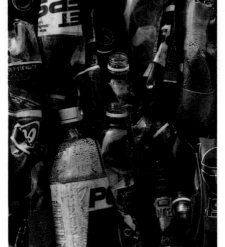

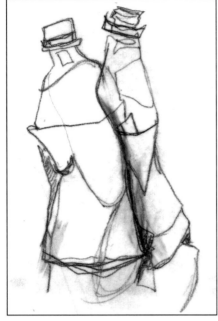

below

STEP ONE

Make a Finished Drawing
Using the thumbnail as a blueprint, make the final drawing. Notice how much rounder and more playful I've made the lines, especially in the Pepsi bottles. Twisted lines really twist, and the folds are simplified and exaggerated.

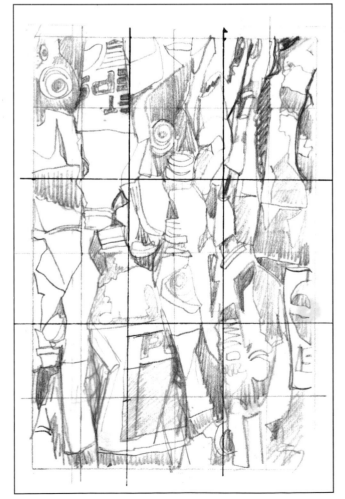

Thumbnail

Final Drawing

STEP TWO

Set the Initial Wash

Use a 1-inch flat synthetic brush in broad overlapping strokes for the underpainting. Color placement is not as important as the even-glowing, constantly changing color. This glaze contributes to the connected quality of the finished painting.

TIP: Begin With Four Colors

Because acrylic paints dry so quickly, only place out these four colors on your palette for the first step.

- Naples Yellow
- Medium Magenta
- Cerulean Blue
- Cobalt Blue

Add other colors as you need them during the painting process.

STEP THREE

Lay In the Darks

For me, the darkest areas of a painting are the foundation upon which all other colors are built.

Mix the darks at 90 percent full value. To keep the colors clear and unclouded, use only staining colors. The idea is to paint all the darks in one value, but not in one color. For example, you might start by mixing Phthalo Blue, Phthalo Green and Dioxazine Purple thinned with flow improver solution. The next time you load your brush, mix in some Mars Black, reload it, and mix a new dark of Phthalo Blue, Quinacridone Violet and Mars Black. Never mix the darks the same way twice—always maintain their value.

By now, you should have laid out all your dark colors on the palette. Next, take a no. 8 round watercolor brush, load it with clean flow improver solution and add a drop of water to each color. This does not dilute the pigment, and it keeps the paint moist, soft and pliable for several hours.

STEP FOUR

Do a Value Study

As you continue to paint the darks, start to thin the colors with flow improver and paint in your value study. The value study is the blueprint for the rest of the painting. Add the following colors to your palette: Naples Yellow, Cerulean Blue and Medium Magenta. The light patterns are established, as well as the placement of highlights and middle values.

> ### TIP: ACRYLIC FLOW IMPROVER
> In a ½-pint container mix one part acrylic flow improver to twenty parts water. Acrylic flow improver increases flow of acrylic colors with minimal loss of color strength and is especially useful for hard-edge painting techniques. For opaque brushwork, you can use the tube paint with the flow improver solution alone. For a wash, thin the pigment with the flow improver solution and some water or gel medium. It should be clear and about the consistency of milk.

STEP FIVE

Full Palette

Now you are ready for a full palette of colors. Clean the old paint off the palette and mixing area. Fill in the largest areas of color next, using a no. 4 or no. 5 round Winsor & Newton Scepter Gold watercolor brush. Note the large areas of red, Cerulean Blue and dark blues and greens.

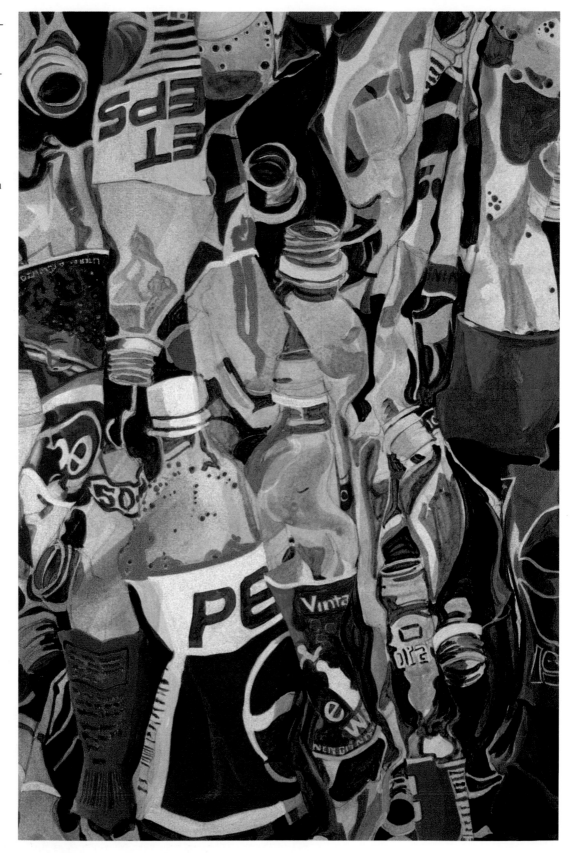

STEP SIX

Detail

Here's a close-up of a typical section of bottle. Work on one area until it is right. Working on a small area at a time allows you to blend the most edges of paint. Once you have the darks in place, paint the highlights and white cap ring. Small areas of reflected green color are suggested.

STEP SEVEN

Detail

Start to build up the highlights on the bottleneck. Use thicker paint to emphasize the brightness. Block in the lightest values of Cerulean Blue, green and yellow. Mix gel medium with highlights to achieve correct consistency.

STEP EIGHT

Detail

There is a lot of reflected color on this bottle. Notice all the speckles of green. The entire area must be covered with paint. With the darks and highlights painted, you can layer in your middle values, designing and redesigning the shapes. Always keep the paint quality on your mind: Are the brushstrokes clean? Is the color accurate? Clean and reload the palette throughout the painting process as necessary.

STEP NINE

Finish

For a final touch, pick up brush-loads of pure pigment on your small brush and add small specks of accent strokes where they are needed. A drop of pure Cadmium Red on a yellow label, bright Yellow Ochre on a bead of water, Cerulean Blue on the lip of a bottleneck. All these colors appear elsewhere, but by accenting dark areas or highlighting a dull edge, the painting becomes connected and the eye moves around smoothly.

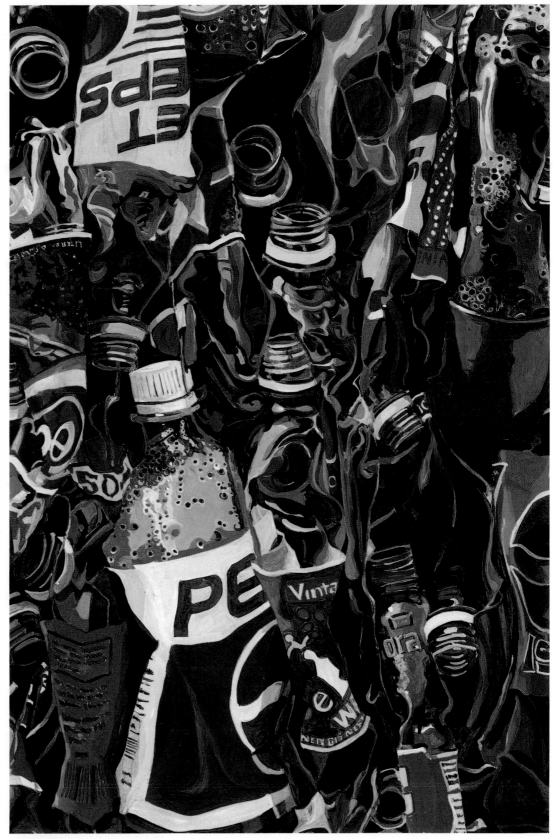

BOTTLENECK
13¾" × 21"
Lisa Buck-Goldstein

Buck-Goldstein Gallery

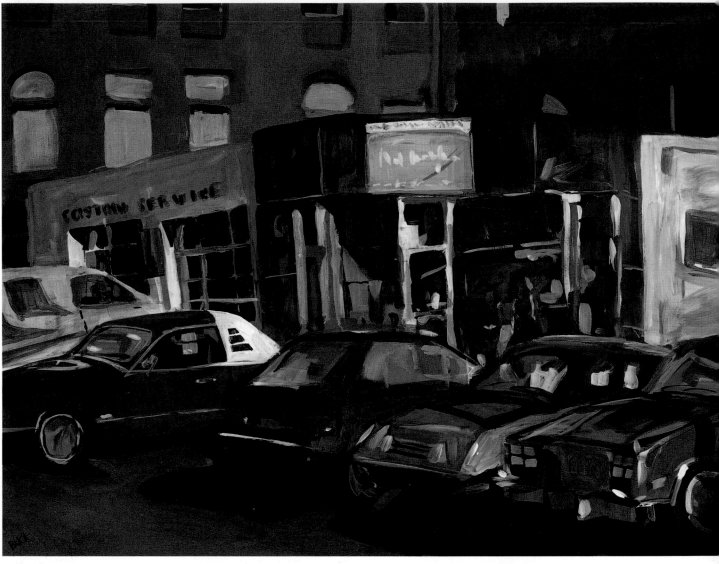

SERVICE STATION
24" × 30"
Lisa Buck-Goldstein

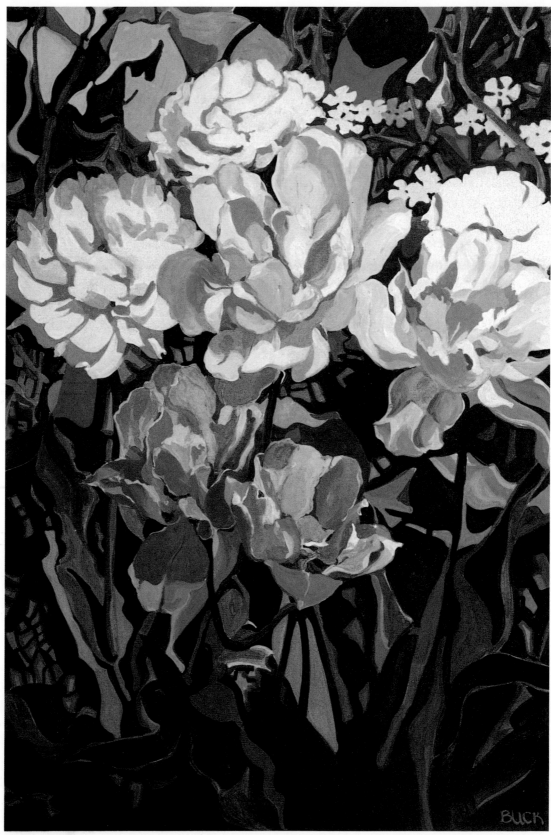

SUNDANCE
20½" × 13½"
Lisa Buck-Goldstein

When painting white, never use pure Titanium White. It has a harsh, chalky effect. When the light is warm and direct, try mixing in a small amount of Naples Yellow or Yellow Ochre, as I have done in the upper left tulip. Add weight and richness to the highlights with medium gel acrylic.

Build Luminosity With Multiple Thin Glazes

Michael Nevin paints city and suburbs

Michael Nevin was attracted to acrylics more than twenty years ago because of their simplicity, directness and versatility. He first worked "flat," that is, without modeling. This method was consistent with his work at the time, which was representational, employing drawing as the defining element—essentially, a graphic style akin to pop art.

Returning to the Midwest in the early eighties, he began to paint in a more traditional way, with a measure of modeling and painterly effects. He continued to paint "thin," a method that allows the underpainting to influence the finished work. He has kept his strong commitment to drawing but, while it's often the foundation of his work, it's less prominent in the finished work. His rule is, "The simpler the better." The only thinning medium he uses is water, relying on washes for gradation and nuance. He adjusts the ratio of pigment to water as it seems workable.

"I paint because it's what I love to do," says Nevin. "My paintings represent particular places, giving them an immediacy a more generalized approach might not have. What I paint is determined by a combination of visual interest and emotional resonance. I usually don't have to go far from home to find a subject that interests me. If I have an approach to painting, it's that each painting has a promise implicit in its beginnings, and my role is to make the finished work fulfill that promise as best I can."

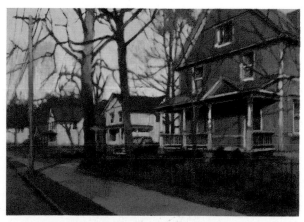

HOUSES, LATE WINTER, CLEVELAND
14"×20", Michael Nevin

Michael Nevin's Basic Technique

On the following pages Michael Nevin uses examples from his painting *Backyards, Winter* to show the basic methods he uses for most of his paintings.

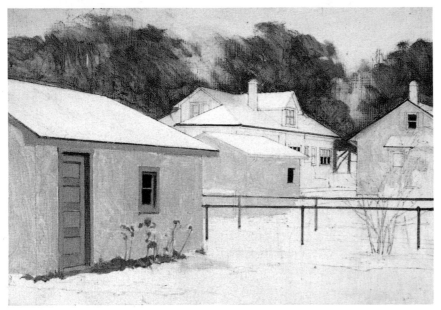

TIP: SEAL YOUR DRAWING
After Nevin works many hours perfecting his detailed pencil drawing on the gessoed panel, he seals it by brushing matte medium, full strength, directly over the completed drawing. This fixes the drawing so that even vigorous brushwork applied over it doesn't smudge or erase the lines; the linear foundation remains intact. This is particularly important in some of his urban scenes that involve complicated perspective and exact proportions.

Draw, Seal and Tone
I sealed the graphite drawing with acrylic matte medium, after which a light wash of Cerulean Blue was applied to the whole surface. Toning the surface (in this case, with Cerulean Blue) serves both to eliminate white, replacing it with a middle value, and to establish the prevailing warmth or coolness of the painting to follow. Sometimes I use a contrasting color, but in this case I set the tone for the prevailing blueness of the scene. I laid in some of the other colors using Titanium White—a cool white— as the base for the buildings. The brushstrokes for the background trees were made in a radiating fashion to suggest the patterns and shapes of the tree masses.

Dilute With Water
For the large shadow across the building on the left, I mixed Ultramarine Blue with Phthalo Blue and Titanium White, cut with about 25 percent water. Diluting the mix suggests the subtlety of the shadow: Full strength would have made it too opaque and heavy.

Painting With Acrylic Washes

A wash of 25 percent water, Ultramarine Blue and Burnt Sienna was applied to the wall of the garage in the center, representing shadow. As it is farther back in space, its color is less intense than the shadow falling over the garage at the left. By painting with washes, I can build up color slowly, giving depth and texture to the painting.

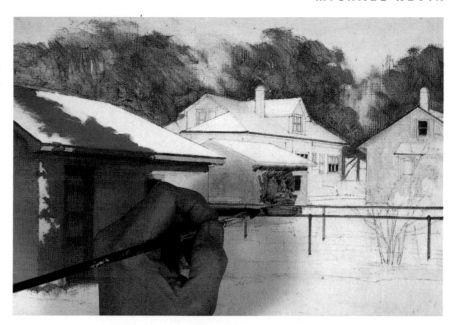

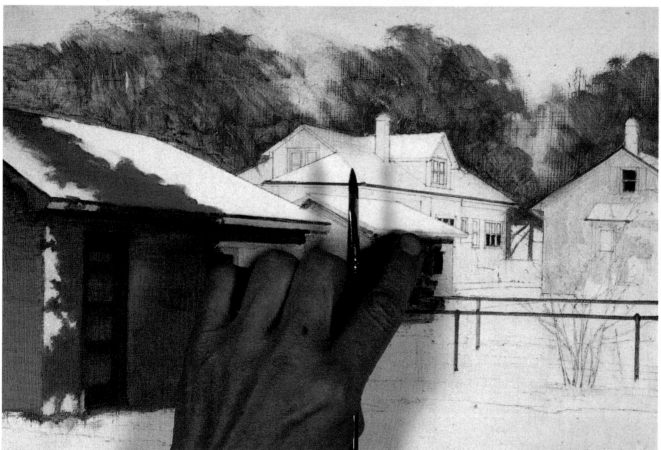

Finger Painting

I frequently use my fingers to blend or soften a wet area. Here, I found that the paint I had just applied to the garage was not quite what I wanted. It's common to modulate a color once it's laid in, and I find fingers can be useful tools with a rapidly drying medium.

Wet-Into-Wet

The tone was still too dark and overly prominent, so I added an application of Unbleached Titanium at almost full strength, working wet-into-wet.

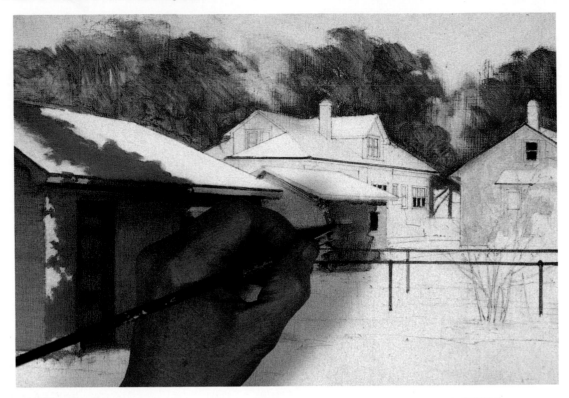

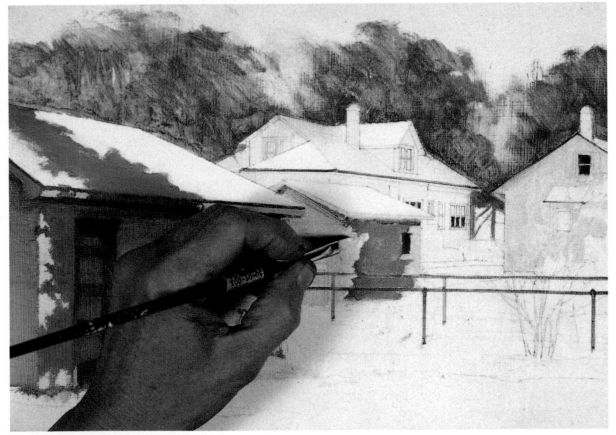

Full Strength White

I then painted the lighted portions of the wall, using Unbleached Titanium and Titanium White full strength. I drybrushed the edge as it met the greenish shadow in order to feather the line, making it softer, in contrast to the sharper edge at the roof line.

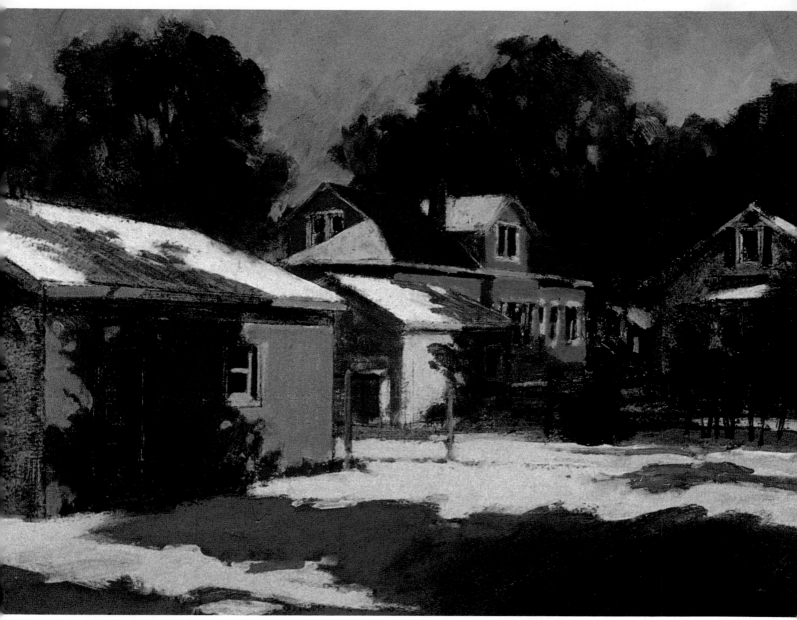

Finished Painting

To complete the painting, I painted the houses in the middle distance in a way similar to the garage discussed above. I painted the large shadow in the foreground with a dilution of 15 percent water. This allowed me to draw the brushstrokes directionally over the plane of the snowy yard, creating a directional force leading into the painting. The sky, Cerulean Blue and Titanium White full strength, joined the trees with drybrush in order to soften the effect. The drama of strong light and shadow transform what might otherwise be a very ordinary scene.

BACKYARDS, WINTER
9¾" × 14"
Michael Nevin

TIP: USE WASHES WITH ACRYLIC

The wash is the method Nevin uses most frequently in developing his paintings. Make a wash by adding water to the paint in varying amounts: The more water, the thinner and more transparent the wash. He says, "I may wipe or blot a wash tone if it seems too strong; I may add more washes over the initial one, once it is dry, to darken the color."

Use Multiple Thin Washes

STEP ONE

Make a Detailed Drawing

Begin the painting by making a detailed drawing directly on the gessoed surface. This design is a composite of several reference photos, with the car at the left added to balance the composition. The signs are an integral part of the picture, and they need to be done right—a crudely done sequence of letters mars what might otherwise be a very skillful piece. The "Fannie May" was drawn from the lid of a candy box.

After completing the drawing, seal it with matte medium to keep the drawing intact. After it dries, lay a light wash of one part Vivid Red Orange and two parts Raw Sienna over the entire surface, giving a vibrant undertone for the portions of the picture in sunlight. (It's easier to subsequently darken than to lighten.)

Color Palette:

- Titanium White
- Unbleached Titanium
- Vivid Red Orange
- Cadmium Red Light
- Permanent Hooker's Green
- Phthalocyanine Blue
- Yellow Oxide
- Raw Sienna
- Burnt Sienna
- Raw Umber
- Burnt Umber
- Red Oxide

Brushes:

- no. 2 Rathbone filbert
- no. 3 Rathbone filbert
- no. 4 London filbert
- no. 16 Wilton bright (for washes)

STEP TWO

Establish Large Patterns

Using light washes, establish the large patterns in the composition. Cadmium Red Light and Red Oxide are combined with 20 percent water for good flow to lay in the signs. "Service Optical" will be rendered in Unbleached Titanium; the red wash will be a bleed around the edges of the letters. "Footwear" is delineated first with Titanium White and Cadmium Red Light. The surrounding dark is added, then the whole word washed with Cadmium Red Light to create the effect of neon light.

STEP THREE

Work on Light Patterns

For the top row of windows, dilute Hooker's Green about 50 percent to indicate blinds, making the spaces between darker. A suggestion of overhead interior lights is seen between the blinds. For the raised letters, paint the shadows first with a diluted mix of Phthalo Blue and Burnt Umber, which is then washed with Raw Sienna to warm the tone slightly. Then paint the letters.

The top third of the painting is complete. Render the mortar in Burnt Sienna, cut with 15 percent water. Paint the bricks with Unbleached Titanium and a small amount of Vivid Red Orange used full strength to maximize the effect of sunlight. The stone band just below the brick walls and windows is initially Raw Umber, a hue with a high degree of transparency. Make a second application adding Unbleached Titanium, allowing the initial coat to define the cleft's pattern.

Darken the street with a wash of Phthalo Blue and Burnt Umber. Use Unbleached Titanium and Phthalo Blue for the light patterns cast from the "el" tracks overhead. The street in shadow will be painted around these light pools or bands.

Complete the "Service Optical" sign using Unbleached Titanium and Raw Sienna plus Raw Umber, full strength, allowing the bleeds of red-orange around them to remain.

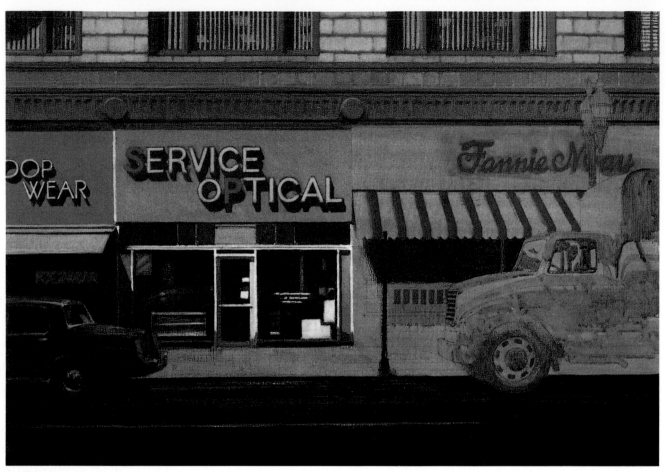

STEP FOUR

Work Toward Completion

Now concentrate on the left half of the picture, bringing the car to completion in order to get a feel for how the areas in sunlight will work with those in deep shadows. Develop the "Service Optical" windows using Phthalo Blue and Burnt Umber cut with 20 percent water to give the feel of transparency and reveal the forms inside the store. Use the same mix to darken the street. Use the largest brush with sweeping, horizontal strokes to underscore the feel of the street as a plane. Several applications are necessary to bring the pavement to an *almost* opaque state; I say "almost" because you will want to retain a slight amount of the undertone.

TIP: Draw

Draw freehand with a 3H pencil and, occasionally, a ruler. Drawing freehand allows you to familiarize yourself with the subject and to work out problems of perspective and proportion. I enjoy it. Drawing is the foundation of my work and, when I do complicated urban scenes, I often spend as much time on the drawing as I do on the painting.

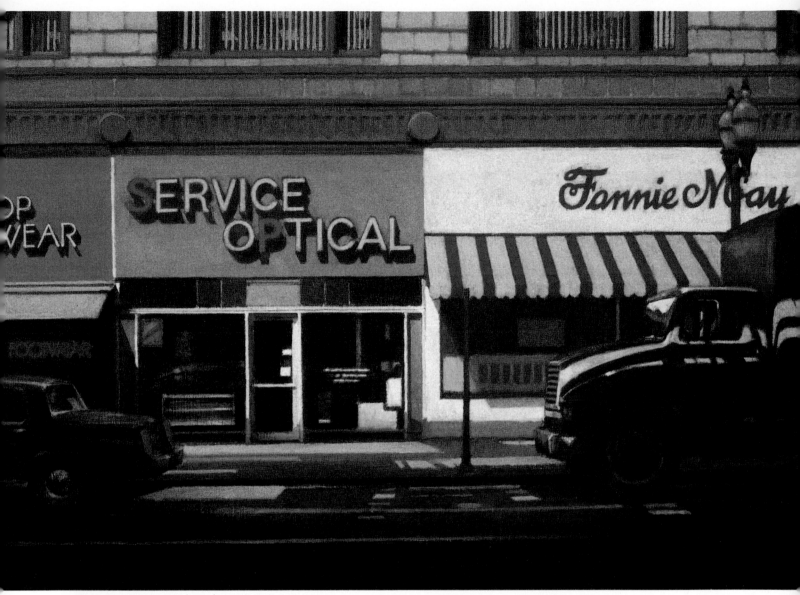

STEP FIVE

Finish the Painting

Use Titanium White full strength to complete the ''Fannie May'' sign. Use Unbleached Titanium for the awning stripes and lighten the pavement toward the curb. Intensify the bands of light on the pavement with Unbleached Titanium combined with Vivid Red Orange and Raw Sienna.

Streetlamp

Render the streetlamp above the truck in thin applications of Unbleached Titanium and Raw Umber. Add Phthalo Blue for the darkest accents. By painting ''thin,'' you allow the warm, yellowish undertone to resonate with what you add over it, keeping the color alive and vibrant.

Truck

Paint the truck in Burnt Umber, darkened with Phthalo Blue, applied full strength. Where the contour changes into light, cut the mix with 20 percent water. Render the patterns of light on the truck by applying a Vivid Red Orange wash, then painting over it with a combination of Titanium White and Yellow Oxide. Allow the red-orange to show at the edges for a more vibrant effect and to act as a transition to the dark areas. The reflection in the vertical plane is rubbed back, then washed with Cadmium Red Light to reflect the sign and storefront.

After making a few final adjustments, seal the painting with acrylic matte varnish.

SERVICE OPTICAL
14"×20"
Michael Nevin

Paint Urban and Suburban Scenes

Although they are not always the primary focus, most of my work contains architectural elements. They suggest a human presence even when no figure is actually seen. As forms, they are often complex and invariably interesting foils for light and shadow, a major element in my paintings.

TIP: WeT Surface

A "wet appearance," such as that of a rainy street, is achieved in two steps. First, apply the paint wet, as in a wash, resulting in a soft-edged transparency that itself suggests "wet." Then you can paint in reflections on roofs, streets and sidewalks, keeping the paint semi-transparent and the edges soft, to complete the effect.

LAKE RYAN TRAIN AT ASHLAND STATION
13½" × 21¼"
Michael Nevin

TIP: Opaque Applications

Opaque applications are useful in creating high color intensities, a feeling of solidity in forms where desired, and highlights or accents. "Opaque" means paint of sufficient density to completely cover the paint layers under it. For opaque areas, Nevin uses the paint at full strength without the addition of water.

FARMHOUSE, FULTON COUNTY OH, #2 *7" × 9¼", Michael Nevin*

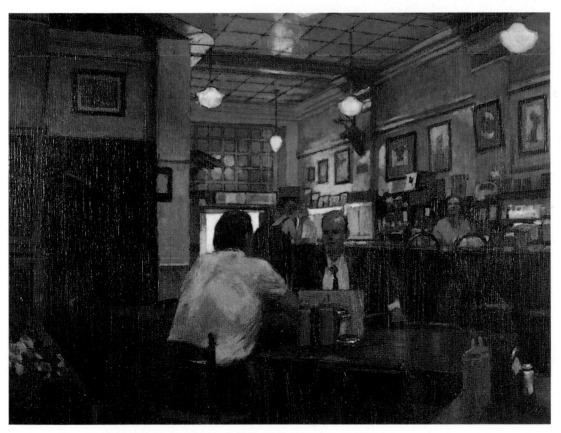

LUNCH AT OTTO MOSER *14" × 18½", Michael Nevin*

Nevin Gallery

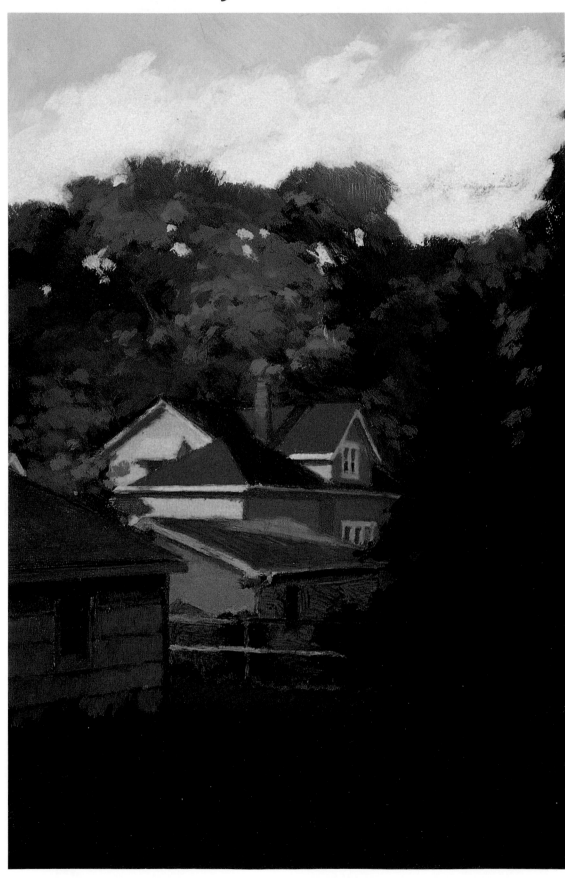

BACKYARD,
LATE
AFTERNOON
12" × 8¾"
Michael Nevin

TIP:
Shining
Chrome
For the effect
of shining
metal, use Ti-
tanium White
straight from
the tube. Its
brilliance,
combined with
its coolness,
read as
chrome.

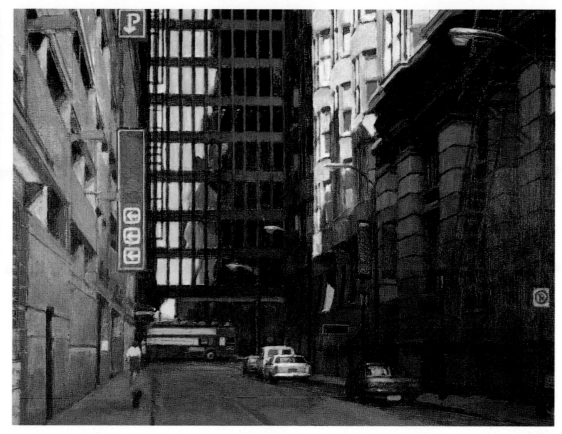

FEDERAL STREET, CHICAGO *14"×20", Michael Nevin*

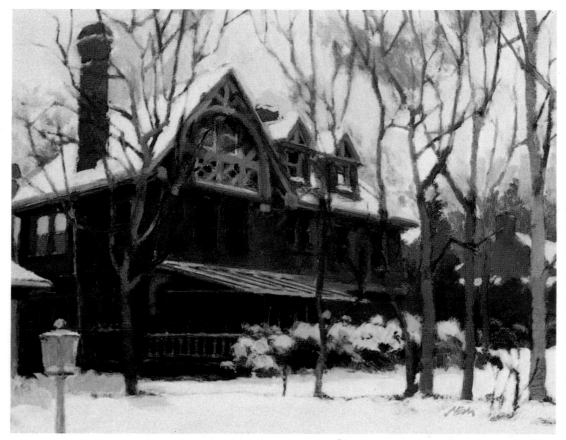

HOUSE AFTER
A SNOW
9¼" × 14"
Michael Nevin

109

Perspective:
Invented in Italy in the
13th century, the sys-
tem shows near and
far. Botticelli fore-
shortened the lower
part of the infant's
legs to give them
when they s
in th
ane

LOUISE CADILLAC

CHAPTER SEVEN

Unlock the Imagination With Experimental Techniques

Louise Cadillac creates expressive abstracts

What does *experimental painting* conjure up in your mind? Bizarre and exotic materials applied with weird implements in unusual ways? Well, yes, but it also includes subtle experimentation in gradual increments and problem solving. Experimenting is more exciting, productive and gratifying with acrylics, and its user-friendly properties, especially its fast drying rate. It's this property that allows for Louise Cadillac's experimentation.

The fast drying rate permits several painting techniques in quick succession. It allows experiments to be wiped away, and others applied over the top. Washes or coats of paint can be layered one over another, to produce the effect she's after. Overlapping transparent layers produce new colors, and unexpected textures.

Cadillac keeps a small pad and pencil right next to her palette, so she can jot down new things she discovers. When she can reproduce the fresh, accidental-looking results at will, she doesn't consider it experimental; it becomes part of her skills repertoire. She experiments incrementally as she paints. When she senses her work is too facile, it's time to risk. She then sets up a seemingly unsolvable problem. She may not solve it, but the impetus opens new avenues to explore.

Before long the work is vital again. Perhaps that's the real advantage of acrylics—you can revitalize your work almost immediately!

MADONNA
FRAGMENTS
30"×22"
Louise Cadillac

Create Texture and Depth

The following pages show some of the techniques Cadillac used to create the interesting textures and depth in *Contra: Clan*. She uses a cut mat as a general mask around the area she is painting and turns the painting as she works.

Stamping with palette knife

Plastic sheet pressed into wet paint

Paint over collage

Bubble-wrap imprint

Lines scratched with plastic palette knife

Paint removed with masking tape

Paint lifted with towel and brayer

Edges left after paint is washed away

Stencilled sharp edges

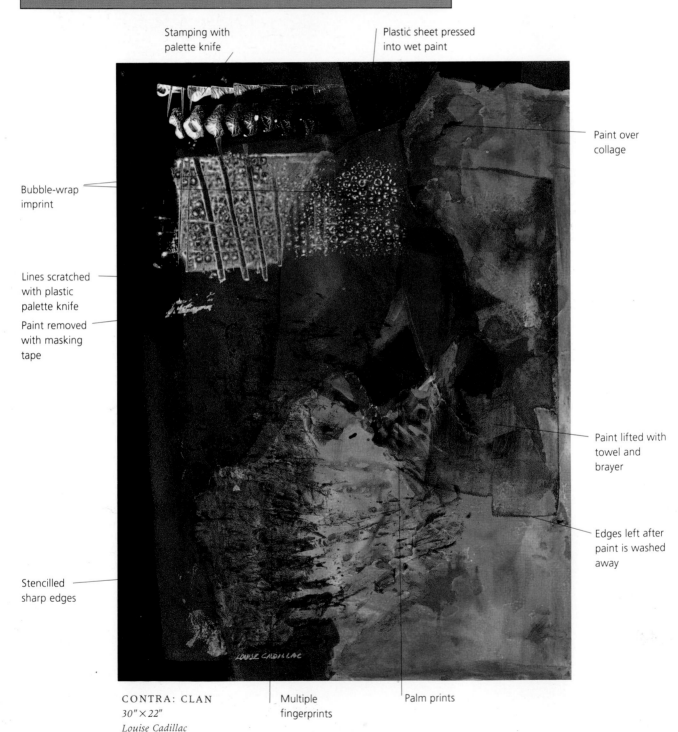

CONTRA: CLAN
30" × 22"
Louise Cadillac

Multiple fingerprints

Palm prints

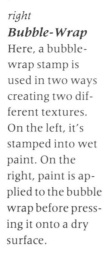

above
Stencilling
A sheet of paper masks off an area creating rectilinear shapes.

right
Bubble-Wrap
Here, a bubble-wrap stamp is used in two ways creating two different textures. On the left, it's stamped into wet paint. On the right, paint is applied to the bubble wrap before pressing it onto a dry surface.

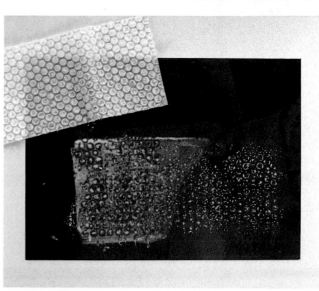

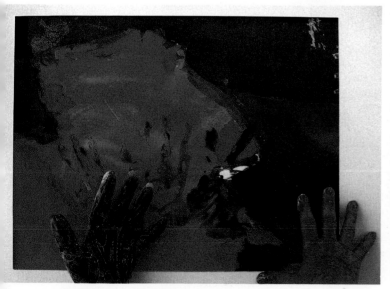

left
Use a Palette Knife
Use the side surface of a palette knife as a stamp to form a repeated pattern. You also can score lines through the bubble-wrap print.

Make Palm Prints
Paint the palm on your rubber-gloved hand and print.

Make Multiple Fingerprints
Apply paint to the fingers of a rubber glove; make multiple and overlapping prints to form a unique texture.

Create Surface Interest With Texture

Following are some of the techniques used in *Montage*. Cadillac lays a cut mat around the area that she is working on, and often turns the painting every way, even upside down, as she works.

Textures created by drawing with alcohol

Stencilled shapes

Checkerboard pattern using an eraser block

Patterns created by stamping with crumpled paper towel

Corrugated cardboard imprint

Scratches

Scraped-off layers

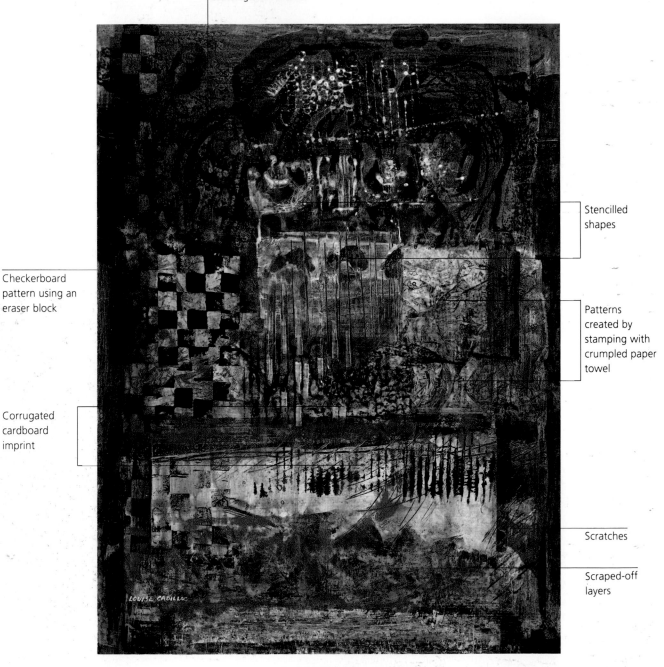

MONTAGE
30"×22", Louise Cadillac

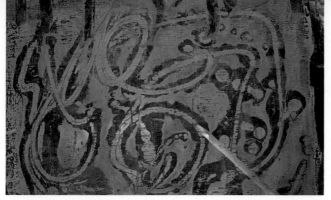

Draw With Alcohol

Form a rich background texture by drawing with alcohol into wet paint. Dip a dowel, pencil or the handle of a brush into alcohol and use it to draw. The exposure of the underlying layers adds another dimension.

Crumpled Towel

After adding more color over the alcohol resist area, use a crumpled paper towel to stamp into the adjacent wet paint. The paint lifts off, making interesting random marbleized patterns.

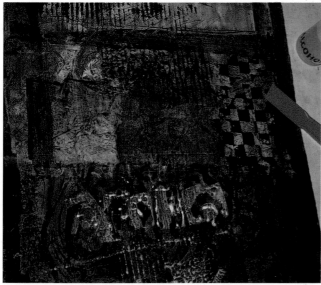

Checkerboard

Working on the painting upside down, glaze over the white areas. Create a checkerboard pattern with an eraser block. By this time, the full richness of built-up, layered textures is becoming very exciting.

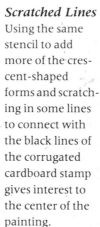

Repeating Stencils

Stencil an interesting shape several times to form a unit. I used a found piece of metal.

Scratched Lines

Using the same stencil to add more of the crescent-shaped forms and scratching in some lines to connect with the black lines of the corrugated cardboard stamp gives interest to the center of the painting.

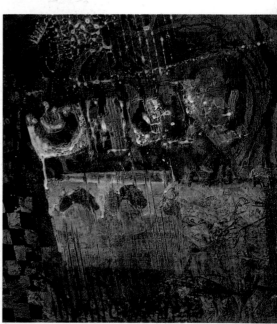

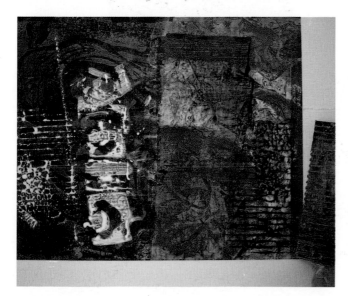

Corrugated Cardboard

Add to the already interesting textures by using a piece of corrugated cardboard to stamp texture in several areas of the painting, some in white and some in black.

Resist Techniques: Alcohol

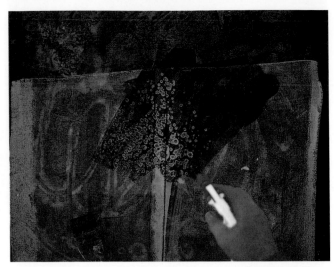

Spray
This is an example of alcohol sprayed into wet paint.

Variety of Textures
Since alcohol resists the water in acrylic paint, it makes a great tool in resist techniques. The upper portion of this paper is an excellent example of the variety of textures that can be achieved by using alcohol in various ways.

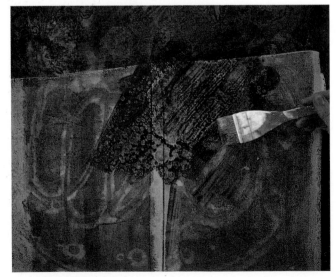

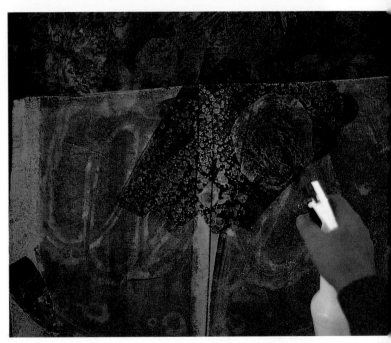

Puddle
A stream of alcohol is allowed to "puddle" in an area, producing a large floral shape.

Granular Texture
Applying paint over the puddle of alcohol produces a granular texture, shown here.

Resist: Paraffin

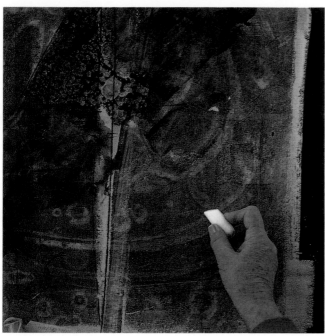

Paraffin Candle

Paraffin is another resist material. In this slide, I've drawn some lines with a bit of candle. The lines become visible only after paint is applied over them.

Create Texture

Red paint brushed over paraffin lines produces another texture over the underlying layer.

Add Color

Wax crayons or oil pastels may be used in the same way. The advantage here is that they add color of their own.

Use a Wash

Brushing a blue wash over the yellow crayon adds yet another color to this area.

Lifting Techniques

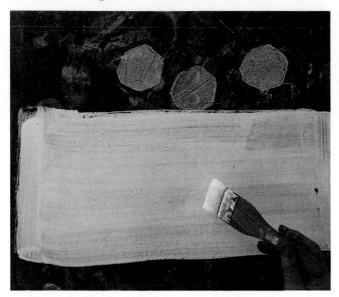

1. Brush on Paint
Brush on an area of opaque paint over other layers of paint.

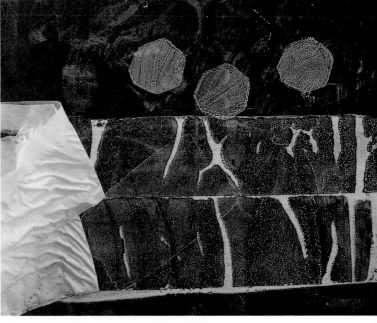

2. Create Patterns With Toilet Tissue
Lightly drop or place toilet paper over the newly painted area at random. Gently lift off the toilet paper and discard. The patterns that result are quite dramatic.

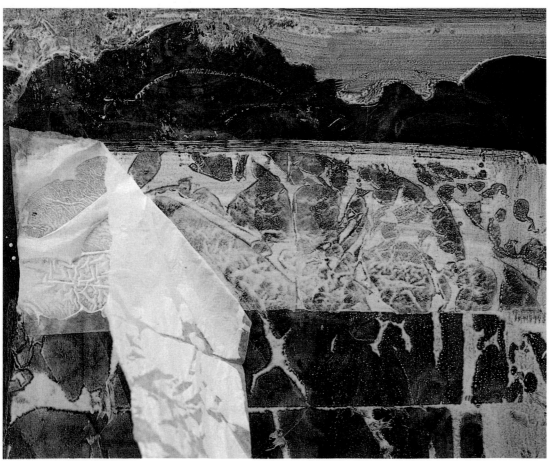

3. Create Patterns With Tissue Paper
Use the same technique with tissue paper for a different type of texture. Different absorbency properties create a difference in textures.

Painting Over Collage

1. Apply Collage and Paint
Collage an area with torn paper. Brush on paint over a large area including the collage. The collaged area receives the paint differently.

2. Create Shapes
While the paint is still wet, use paper towels and a brayer to create rectangular shapes in the newly painted area.

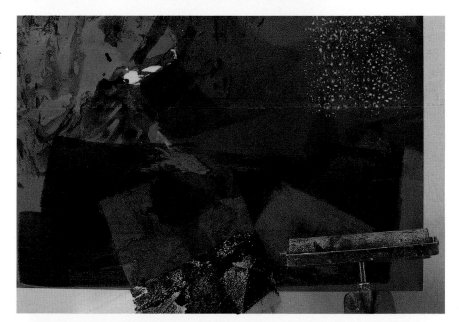

3. Interesting Edges
Scrub away more of the wet paint with a wet or damp paper towel. The paint around the edges, which has begun to dry, remains, forming interesting edges outlining the painted area.

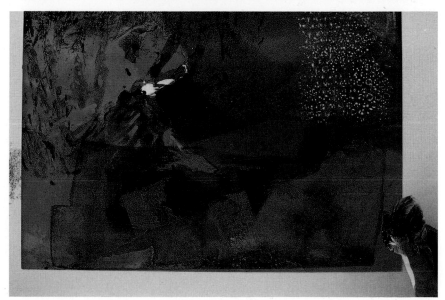

Sizing and Taping Techniques

1. Sizing

Before painting, apply sizing to a small patch of the paper. Acrylic mediums make good sizing, either full strength or mixed half-and-half with water. Apply paint after the sizing has dried. The un-sized portion of the paper accepts much more paint and therefore appears darker.

2. Remove Paint

Paint is more readily removed from the sized area, creating a variety of textures. Use a damp or dry towel, or wash it off under the faucet.

1. Using Tape

Brush paint over an area that has been masked off with a piece of masking tape.

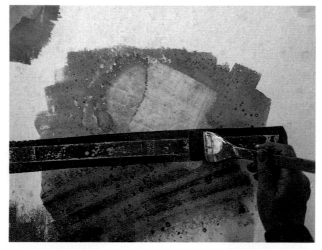

2. Remove Tape

Removing the tape reveals the layers underneath.

3. Different Effects

Try using multiple layers of masking tape to produce many different effects. Opaque paint or transparent washes may be used with varying results.

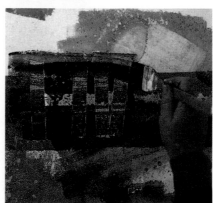

4. Exciting Layers

Remove the tape and expose the layered effects, which are now becoming quite exciting.

Scraping and Scratching Techniques

Kitchen Spatula
A rubber kitchen spatula is used to scrape paint off metallic paper that has been collaged to the surface. The left edge of the metallic paper has been ''scraped'' away, leaving a sensuous, ragged edge.

Squeegee
Try using a squeegee to drag paint over large areas.

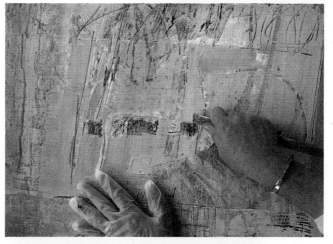

Found Objects
Any instrument or found object may be used for scratching and scraping.

Palette Knife
An angled palette knife is used here scraping into a wet layer revealing broad bands of the color underneath.

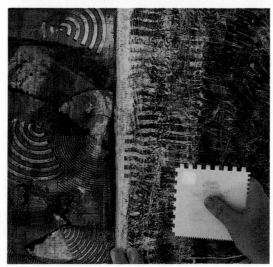

Grout Spreader
This grout spreader from the hardware department has four different sides that produce various multiple lines. Although these multiple lines are quite mechanical, they may be done in a variety of sensuous and expressive ways.

Cadillac Gallery

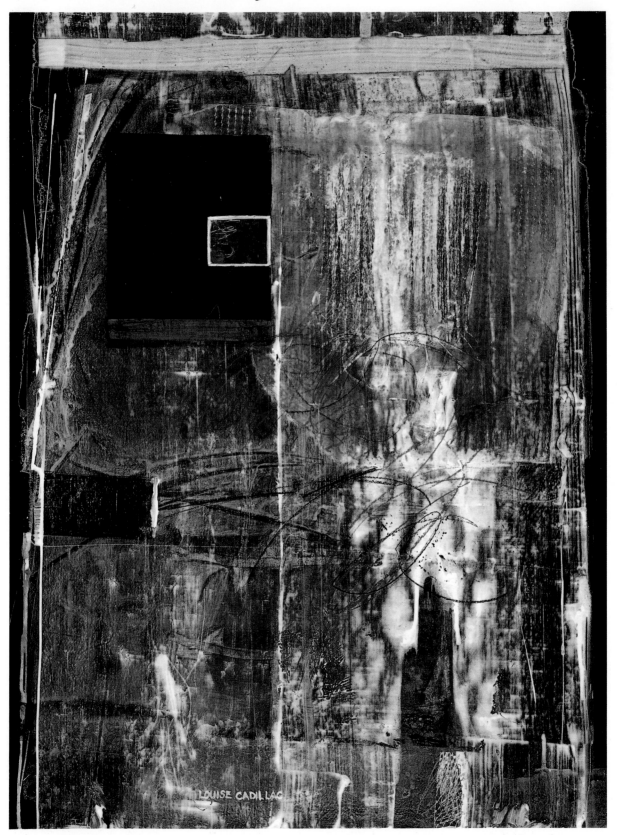

PINK SQUARE 30"×22", *Louise Cadillac*

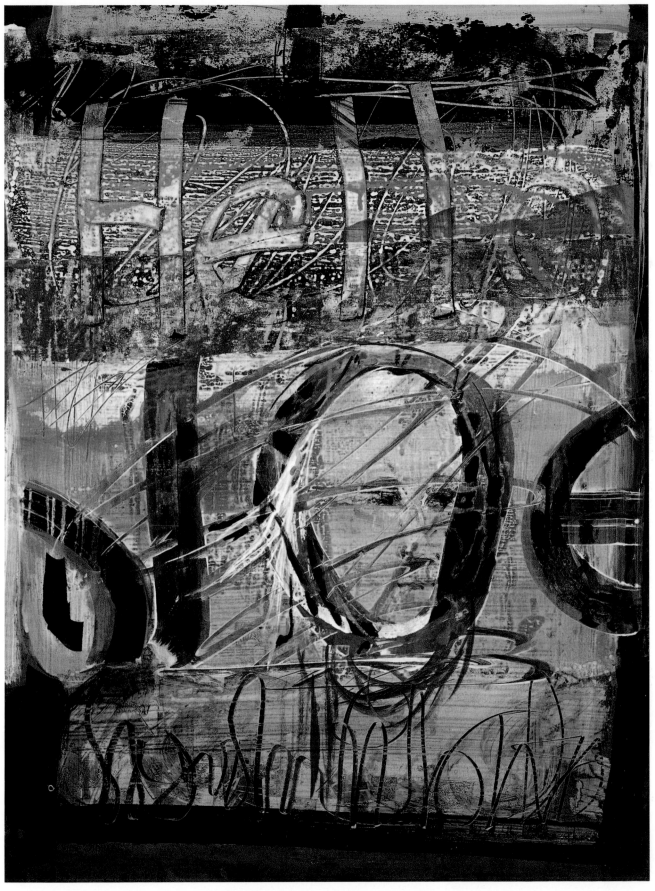

CONTRA: CODY 30"×22", *Louise Cadillac*

About the Artists

Joseph Orr

As a machine operator at Hallmark Cards in Kansas City, Joseph Orr developed an interest in the art on the greeting cards passing through his machine. After two years of private art lessons and painting every available minute, he left Hallmark to be a full-time artist. Since that time, 1972, he has concentrated on the medium of acrylic. Orr has been included in invitational and museum exhibits across the country, including the Society of Painters in Casein and Acrylic, the Knickerbocker Artists and Salmagundi Club Annuals in New York City. Group exhibits include the Albuquerque Museum, the Gilcrease Museum in Tulsa and the Old West Museum in Cheyenne, Wyoming.,

Orr has also been included in the prestigious The Arts For The Parks "Top 100" Competition in Jackson, Wyoming, three times. In 1993 his entry won the Historical Art Award and was featured on both the National Parks calendar and the stamp. Feature articles on his painting have been printed in *American Artist, Midwest Art* and *The Artist's Magazine* and his work is included in *Acrylic Painting Techniques* by Earl Killeen (North Light Books, 1995). He is listed in *Who's Who in American Art*. Orr works from his studio and outdoors in the rural countryside surrounding the resort community of Osage Beach, Missouri. The following galleries represent his paintings: Altermann & Morris Galleries in Santa Fe; Leopold International, Kansas City; Quast Galleries in Taos; and Trailside Americana Galleries in Scottsdale, Arizona.

Mary Sweet

Mary Sweet has always drawn and painted. She began her art studies at Walnut Hills High School in Cincinnati and went to Stanford University to major in art. She graduated with a B.A. in Art with Honors in Humanities. She went on to get an M.A. in Art at Stanford the following year.

She studied with Professor Daniel Mendelowitz, author of *A History of American Art* and *A Guide to Drawing*, who taught both art history and watercolor courses at Stanford. After moving around with her Navy husband for a number of years, they settled in New Mexico, where Sweet still lives.

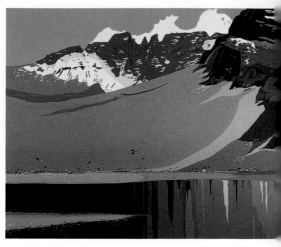

MARY SWEET

The land and our relationship to it and nature are very important to her. She has been alarmed for many years by what we as a society have done to the environment in ignorance, carelessness and greed. The grandeur of the natural world and concern about its future are her subject matter.

Barbara Buer

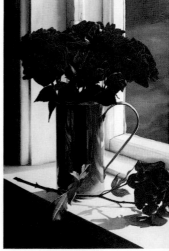

Barbara Buer is a signature member of both the American Watercolor Society and the National Watercolor Society. BARBARA BUER She is represented by Capricorn Galleries in Bethesda, Maryland, and by the William Ris Galleries in Camp Hill, Pennsylvania and Stone Harbour, New Jersey. She is an instructor of art at The Art Center School and Galleries in Mechanicsburg, Penn-

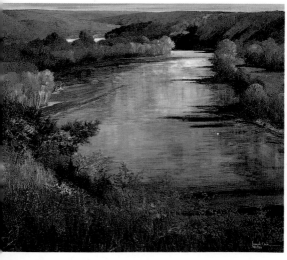

JOSEPH ORR

WILLIAM HOOK

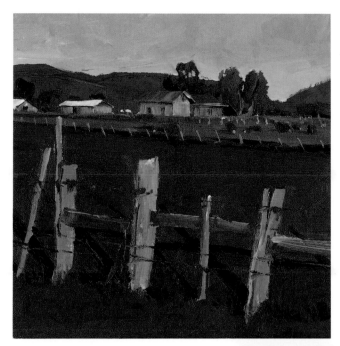

LISA
BUCK-
GOLDSTEIN

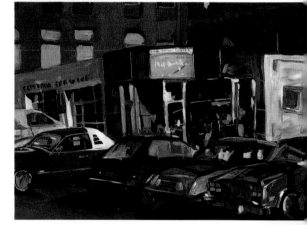

sylvania, where her work is continually on display in the Center's Sales Gallery. Her work is included in numerous corporate and private collections. In the spring of 1996, an exhibit of her work was presented by the Washington County Museum of Fine Arts in Hagerstown, Maryland.

Her work has been included in exhibits at the Butler Institute of American Art in Youngstown, Ohio; the Allentown Art Museum in Allentown, Pennsylvania; the William Penn Memorial Museum in Harrisburg, Pennsylvania; the Alleghenies Museum of Art in Loretto, Pennsylvania; the South Bend Regional Museum of Art in South Bend, Indiana; and the Fitchburg Art Museum in Fitchburg, Massachusetts.

Her work has appeared in North Light Books' Splash series, editions 1 and 4, *The Best of Flower Painting 1* (North Light Books) and *The Best of Watercolor Florals* (Rockport Publishers), as well as these magazines: *The Artist's Magazine, Palette Talk* and *Watercolor Magic*.

William Hook

Colorado artist William Hook is the product of a creative Kansas City family. Artist relatives included a photographer, an architect, an art history professor and a painter, all of whom made it nearly impossible for Hook to be anything other than an artist. He has studied at the Kansas City Art Institute, the University of New Mexico, the Los Angeles Art Center College of Design and the Universita per Sranieri in Perugia, Italy. These nine years of concentrated studies with American and European artists have resulted in a style

that is uniquely his own.

Acrylic on canvas is the medium of choice for Hook, and landscapes are his most often explored subjects. "I try not to let my education get in the way of my learning, and I suppose that a landscape allows me to explore the limits of my creativity," Hook admits. His interpretive style of painting has been featured in cover stories for *Southwest Art, Art of the West, U.S. Art* and *American Artist*.

Lisa Buck-Goldstein

Originally from Massachusetts, Lisa Buck-Goldstein received her B.F.A. in Graphic Design from the Massachusetts College of Art in 1976.

From the late seventies to the eighties she lived in New York City where she worked as an Art Director for several major companies. During this period she studied wa-

tercolor at the Parsons School of Design and Pratt Institute. She continued her studies in painting with Don Andrews, A.W.S.; Judi Betts, A.W.S.; Al Brouillett, A.W.S.; Marbury Hill Brown, A.W.S.; Jacqui Morgan; Charles Sovek; Howard Watson, A.W.S.; and Frank Webb, A.W.S.

She is a signature member of both The Philadelphia Water Color Club and the Pennsylvania Watercolor Society, has taught painting with the Pennsylvania Center for Arts and served on the Monroe County Arts Council Board of Directors for five years. Her work has been published in *Splash 4: The Splendor of Light*.

Michael Nevin

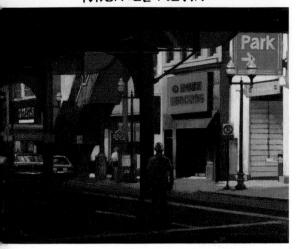

MICHAEL NEVIN

(photo credit: William Nevin)

Michael Nevin has been making pictures almost all his life. As a child, he received a scholarship to the Art Institute in his native Dayton, Ohio. As an adult, he studied first at the California School of Fine Arts in San Francisco, then at the Cleveland Institute of Art, where he graduated in 1964. He taught art for a number of years, keeping active as a fine artist. In 1982, he returned to the Midwest and found new inspiration in its landscapes, urban and rural. Since that time he has concentrated on capturing the lights, moods and seasons of the Midwest.

Nevin has exhibited in a large number of national competitions. Among them are the Salmagundi Non-Members Exhibition, the Knickerbocker Artists Annual, the Allied Artists of America Annual and the American Artists Professional League Grand National, all in New York. He has also exhibited in the American Realism Exhibition in Parkersburg, West Virginia; "Realism Today" in Evansville, Indiana; the Akron Society of Artists Grand National Exhibition; the National Oil and Acrylic Painters Society Annual; and both the American Watercolor Society and the National Watercolor Society annuals. He received awards in the last four of these exhibitions as well as from the Rocky Mountain Watermedia Exhibition and the Knickerbocker Artists Annual. His work has been featured in *The Artist's Magazine* on several occasions and in July 1995, was the subject of a cover article.

Louise Cadillac

(photo credit: Charles Cadillac)

Cadillac won the Gold Medal of Honor in the 1992 American Watercolor Society Exhibition and the First Place Award in the 1991 Rocky Mountain National Exhibition. She has earned national acclaim as a workshop teacher and as a juror in watercolor competitions. Most recently, Cadillac chaired the awards committee for the American

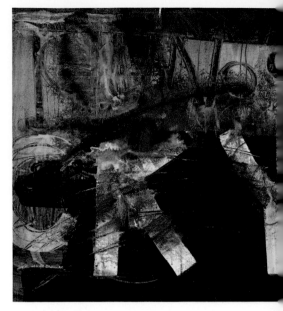

LOUISE CADILLAC

Watercolor Society's 1996 exhibition.

Cadillac's work is featured in *Splash 1, 2* and *4* (North Light Books), in *Best of Watercolor Abstracts* (Rockport Publications) and in Vicki Lord's *First Steps in Painting With Acrylics* (North Light Books), as well as several of Gerald Boomer's books.

Following her distinguished career as an art educator in public school and higher education, she was awarded the Vincent Van Gogh Plaque for outstanding leadership in arts education.

In addition to teaching regularly scheduled workshops in the United States, she teaches in various parts of the world including Acapulco; Ontario and Victoria, Canada; and in Italy.

INDEX